IMAGES
*of America*

# AROUND
# SAN TAN MOUNTAIN

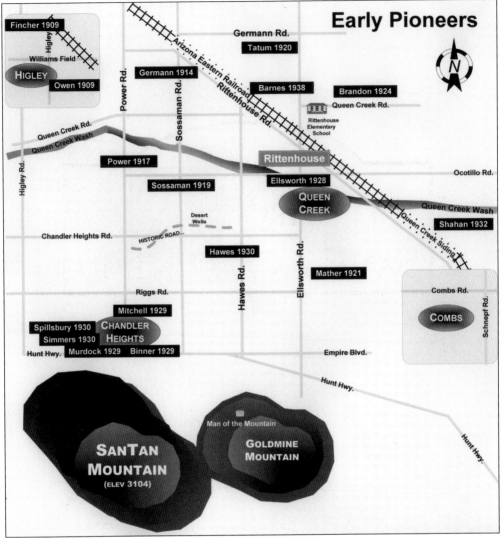

Communities take shape as pioneers and entrepreneurs establish homes, farms, and businesses around San Tan Mountain. (Courtesy San Tan Historical Society.)

**ON THE COVER:** Bill Brandon drives one of the first single-row International Harvester cotton pickers, purchased in 1947 by his father, Charles. Recognized as one of the area's leaders in cotton agriculture, Charlie farmed for over 60 years. These machines revolutionized the cotton-harvesting process. (Courtesy San Tan Historical Society.)

IMAGES
*of America*

# AROUND
# SAN TAN MOUNTAIN

David Salge

ARCADIA
PUBLISHING

Published by Arcadia Publishing
Charleston SC, Chicago IL, Portsmouth NH, San Francisco CA

Printed in the United States of America

Library of Congress Catalog Card Number: 2007921326

For all general information contact Arcadia Publishing at:
Telephone 843-853-2070
Fax 843-853-0044
E-mail sales@arcadiapublishing.com
For customer service and orders:
Toll-Free 1-888-313-2665

Visit us on the Internet at www.arcadiapublishing.com

To the volunteers of the San Tan Historical Society

# CONTENTS

# ACKNOWLEDGMENTS

Like many good ideas, it began with a simple question. An e-mail from Jack August, director of the Arizona Historical Foundation, put this project in motion by asking for a time to meet with me to discuss AHF's relationship with Arcadia Publishing. Foundation members, especially Jared Jackson, stood by me every step of the way.

The San Tan Historical Society is blessed with a number of dedicated members and supporters, many of whom dusted off their photograph albums for this book, including the following: Virginia Mitchell Miner, Betty Binner Nash, Roger Nash, Jamie and Sue Sossaman, Newell and Katherine Barney, Barbara Peacock, Ed and Joyce Nevitt, Barbara Lindsay Smith, Bernadette Heath, Mark Schnepf, Leon Cluff, and Max and Carolyn Ellsworth Schnepf. Delos and Alba Ellsworth's collection of Paul Jones photographs was an important contribution. In 1937, Grace Ellsworth Jones moved to the area with her husband, Paul, a photographer who chronicled the region's development. He was tragically electrocuted in 1945 while working on an irrigation pump.

I depended heavily on the priceless collection of personal stories and family histories compiled by Frances Brandon Pickett in 1996 entitled *Histories and Precious Memories of the Queen Creek Area, Arizona*. Having learned from Sue Sossaman's writings on local history, I hope that this book will in some way return the favor. Her suggestions have been extremely helpful.

My fellow San Tan Historical Society volunteers provided images, information, and recommendations: Betty Maddux, Ron and Donnis Hunkler, Robbie Snyder, Gordon and Nonda Brown, and especially Gloria Greer.

As word of the book spread, community support was overwhelming. I wish to thank Philip Barnes, Maurine Cluff, Laveda Fincher, Mary Camacho, Johnnie Raye Clegg, Myrna Skousen, Ruth Wales, Jim Power, Dan Talbot, Dee Anne Thomas, and Ted Barkley, to name just a few.

My employer, Wells Fargo, is one of only a few companies offering sabbaticals for community service. Thanks to its Volunteer Leave Program, I was able to dedicate time to this project.

The book would not have been possible without the encouragement of my wife, Alicia. Her support motivated me through the many long hours of research.

# INTRODUCTION

San Tan Mountain rises above the desert of south-central Arizona to an elevation of 3,104 feet. It is shadowed on the east and south by Goldmine Mountain and a rugged range of rocky peaks and foothills. White settlers were preceded in this area by a people the Pima called Hohokam, meaning the "vanished ones." Archaeologists date the earliest sites of these pioneering desert dwellers to around the time of Christ. By the year 700, the Hohokam people were thriving in numerous farming villages around San Tan Mountain.

In 1891, Stephen Weaver Higley transferred to a construction job from the main line of the Santa Fe in New Mexico to the Arizona Territory. In 1905–1906, he bought an estimated 8,300 acres of land in the area, believing it to be fertile soil with the potential for farming. The original Higley town site consisted of 40 acres with a general store and post office built in 1910.

It is important to remember that in 1910 Arizona was still two years away from becoming the 48th state. While Francisco Madero was launching the decade-long Mexican Revolution, families began to migrate to the Arizona Territory to escape the violence and to seek the opportunity for a better life.

A few miles to the east of Higley, land developer Charles Rittenhouse started the Queen Creek Farms Company on 1,000 acres of desert. He dug some of the first wells, and soon a little community developed around the railroad siding that had been established to ship produce and cotton. This community was referred to as Rittenhouse.

In 1917, the United States declared war on Germany. Soon after, husband and wife Jesse and Althea Taylor, army veterans, came to the Arizona desert hoping to regain health lost in France during World War I. She was a nurse and he a non-commissioned officer who met in a hospital and married. They worked hard and long to build their home from rocks they carried with care from Goldmine Mountain.

The early 1920s proved to be the defining years for the Higley and Rittenhouse area. Communities grew slowly out of the desert as crops took root on newly cultivated and irrigated fields. Queen Creek Farms grew cotton, vegetables, grapes, and plums; however, the grapes and plums were not profitable, and a significant debt led to Charles Rittenhouse's bankruptcy. Leo Ellsworth capitalized on this situation in 1927, bringing in his brothers to develop an operation that soon consisted of cotton, vegetables, sugar beets, cattle, sheep, hogs, and a dairy herd.

In 1928, Dr. Alexander J. Chandler, a veterinarian, entrepreneur, and first mayor of the city that bears his name, had big plans for the development of a farming community at the base of San Tan Mountain just a few miles west of Rittenhouse. He called the area the Chandler Heights Citrus Tracts. An early 1929 Chandler Improvement Company bulletin reported the following:

> Of all lands in the Salt River Valley now planted to citrus fruits or being prepared for the planting of citrus fruits, the expressed opinions of an impressive group of citrus experts are virtually unanimous in agreement that the new Chandler Heights tract of 5,000 acres of oranges and grapefruit land, recently subdivided and opened to investment, is the finest body of such land ever opened to development in the entire Salt River Valley.

Because of the stock market crash in October 1929, Dr. Chandler's grand vision for investors was never realized, though the community of Chandler Heights continued to play a significant role in the history and folklore of the area. Roger Binner was another World War I veteran to move to Arizona for his health. He had been gassed in the trenches of France while serving with the 101st Army Engineers. The dry air helped with his respiratory problems. In 1929, Roger and Teresa "Tess" Binner purchased 10 acres at $595 an acre. Tess became the first postmaster nine years later. She had worked long and hard to get a post office for Chandler Heights, as receiving mail on a route out of Higley did not meet the needs of the growing community. The Binners' daughter Betty started a weekly newspaper in 1939 at the age of 14.

In 1936, the Aldecoa, Valenzuela, and Trujillo families moved to Rittenhouse and were employed by Ellsworth Brothers Farms. Many worked as irrigators in the vegetable and cotton fields. Others went on to establish businesses that were later known as the heart and foundation of the community.

During World War II, the communities around San Tan Mountain faced new challenges. Many farm workers were now employed by the defense plants, and the farmers found it difficult to get their cotton harvested. A German POW camp was established at Rittenhouse, with 250 prisoners in tents located on the north side of the railroad tracks. During the picking season, the POWs were put into the fields early each morning to pick a daily quota of 125 pounds of cotton. These Germans had never seen or worked with cotton before, and 125 pounds was hard for them to achieve. If they failed to meet their quota after two days, they were placed on rations of bread and water. Soon all were confined to camp, the cotton unpicked. When the farmers protested this treatment, the camp commander was replaced—an improvement that pleased the prisoners and resulted in many friendships with the farmers. One of the POWs was a doctor whose services were used frequently, not only for his fellow prisoners but for community residents as well.

A petition requesting a name change from Rittenhouse to Queen Creek circulated in 1947, and a post office was established in the Queen Creek Fountain and Drugstore. Eva Lena Sherwood served as first postmistress, with Frances Brandon as assistant postmistress. The salary of 56¢ a day was split between them.

According to a 1957 interview, J. O. Combs found it interesting that people had been able to make a productive ranch out of "jack rabbit sagebrush land that could have been bought for 5 cents an acre" when he first came through 30 years before. J. O. purchased his first section of land a few miles east of the Rittenhouse community in 1943. He drilled his first well in 1947 and a second in 1948. And in 1951, J. O. and his partners—Jack Combs and Dike Clegg—produced their first crop. J. O. once said, "It took work and it wasn't all roses, but that is past history."

These are only a few stories. Housing developments, restaurants, and grocery stores have replaced the farms, orchards, dairies, and cotton gins. Artifacts as old as the Hohokam people, who once made this area their home, are still discovered today as ground is prepared for the next generation of development. For some, these changes are disheartening, but for others, they present new and exciting opportunities. One thing is for sure: The people here are special. We can all be very proud of the history that contributes to the richness of the area around San Tan Mountain.

# One

# DETERMINED PIONEERS

Today's residents may not recognize the historical relevance of their daily travels, comfortable in air-conditioned vehicles with bottled water in hand. Leaving a grocery store on Power Road, they might travel east on Germann Road, driving past Sossaman along Rittenhouse to Hawes Road. At Chandler Heights Road, a turn to the east will take them to Ellsworth Road. Each change of direction uncovers a route named for an early pioneer.

In 1914, two years after the area had become a state, most everyone but John and Mathilda Germann thought it impossible to farm on the desert of Arizona. The Germanns purchased a relinquishment of 480 acres from a discouraged homesteader and established their home and pumping plant.

Three years later, J. O. Power moved to the area with his brother Bernard "Buck." Their family homesteads consisted of 320 acres. Jasper Sossaman—along with his mother, Nancy, and his brother Lee—settled homesteads in 1919, after his father died. In 1927, Charles Rittenhouse, facing bankruptcy, sold his property to Leo Ellsworth. Leo and his brothers formed Ellsworth Brothers Farms, soon owning or leasing up to 20,000 acres. A. J. Chandler called his vision Chandler Heights Citrus Tracts. In 1928, he and his sales associates took the lead in the development of a farming community. When Ernest Hawes started farming in the 1930s, much of his property was covered with greasewood and cactus. He cleared and cultivated the land so that his family could grow onions, carrots, cauliflower, lettuce, broccoli, potatoes, grain, and cotton.

These are just a few of the men, women, and children who—along with their neighbors of diverse cultures, backgrounds, and determinations—created communities out of the harsh desert.

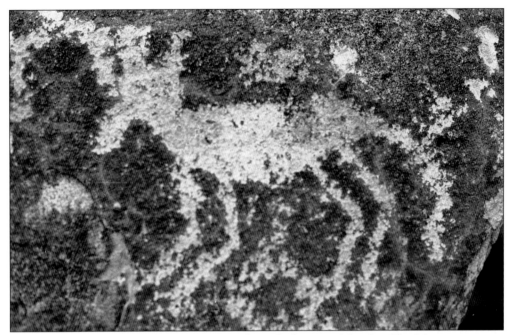

As travelers of the early 20th century came through the gap of the San Tan Mountain range, they would often stop to admire petroglyphs along the road. These prehistoric drawings reminded the visitors that they were not the first to make this trip or to enjoy the beauty of the desert landscape. (Courtesy Bernadette Heath.)

Much of the area was scattered with potsherds, some of which were very beautifully finished and decorated. Artifacts from this prehistoric period were once so abundant that they were considered nuisances by many of the farmers who cultivated the desert. Today they are seen as treasures and can still be discovered occasionally as the desert soil is scraped and dug for new development. (Courtesy Delos and Alba Ellsworth.)

Many are familiar with Casa Grande Ruins National Monument, which was still an impressive structure in the 1930s. Similar to Casa Grande, the area around San Tan Mountain was heavily inhabited by the Hohokam people. Their culture reached a climax between 1100 and 1400, after which, for reasons still unknown, it declined. (Courtesy Roger Nash.)

According to U.S. Geological Survey maps dated 1904, a historic road passed by a well on Andrada's Ranch. The homesteaders called the site Desert Wells; according to folklore, it was a stage stop for the Arizona Stage Company, operating from 1868 to approximately 1916. Freight and stage companies often had arrangements, honored on a handshake with ranchers, for use of local wells and outbuildings. (Courtesy San Tan Historical Society.)

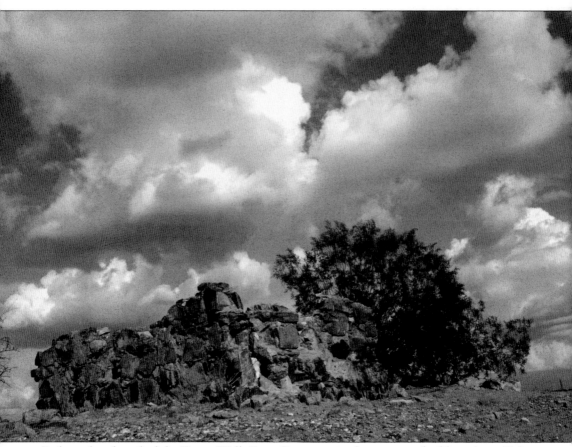

Early settlers described the Desert Wells Stage Stop as a simple, one-room building about 10 feet square, constructed of rock and mud with a thatched roof and awning—a style very similar to Pima Indian dwellings of that time. A trough running around three sides was used for watering the horses and mules. The awning shaded the short walk to the well on the south side. According to homesteaders who have passed along stories about this site, it had one four-foot door and small gun ports instead of windows. Anecdotal tales of discovered bodies and gunfights with Native Americans continue to nourish the imaginations of those who visit this site, located three-quarters of a mile south of Ocotillo Road on the east side of Sossaman Road. (Courtesy San Tan Historical Society.)

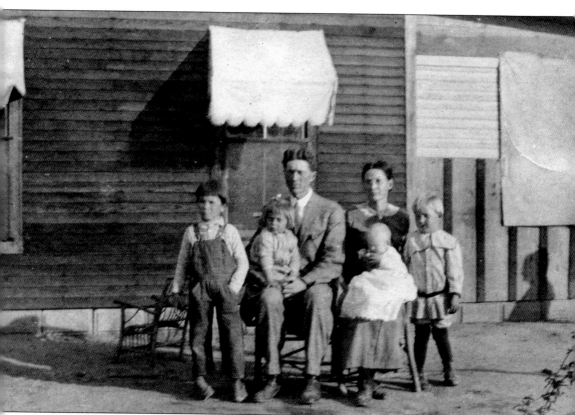

In 1920, Stephan Burchett Tatum moved his family to the Rittenhouse area. This was a time before many conveniences and would be considered extremely primitive by today's standards. Farmers worked their land with horse-drawn machinery that required constant attention. Homes did not include running water or electricity, prompting families to often gather in the evening around the glow of a kerosene lamp. Today a few people can still remember the smell of kerosene and the poor light these lamps produced. During summer dust storms, Stella Tatum would sometimes leave the doors and windows open, claiming that she found less dust settled in the house than when she closed everything up. It is not uncommon for the dust to be blowing, when all of a sudden the skies open up with a heavy rain. And within just a few minutes, everything is covered with a gritty mixture of water and dirt. (Courtesy San Tan Historical Society.)

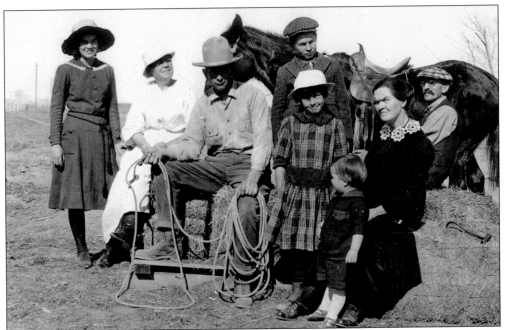

In 1921, Stephen Daniel Mather, together with his wife, Almyra "Myra," moved his family to Rittenhouse from the community of Chandler. In 1919, they proudly posed for this photograph, which shows, from left to right, daughter Faith, Pearl Bouton, Stephen, daughter Ruth (foreground), son Abner (background), son Gordon (foreground), Myra, and an unidentified man. After four years of working together as a family and living in a rented cabin, they were able to settle on their own homestead. (Courtesy Jamie and Sue Sossaman.)

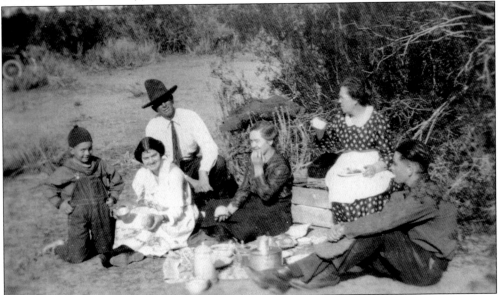

The Mathers were like many of the families in the community. Sunday was the one day of the week reserved for morning religious services and social gatherings, often followed by a picnic in a desert wash with friends and neighbors, when weather and temperatures permitted. (Courtesy Jamie and Sue Sossaman.)

14

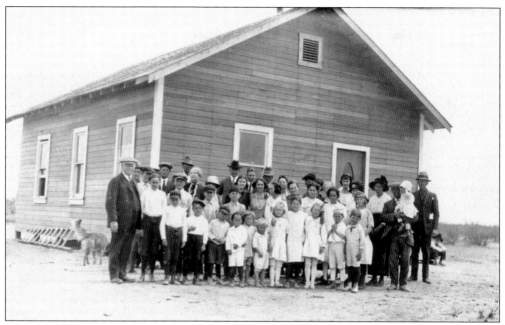

The first church in Rittenhouse was constructed in 1921, just south of the railroad tracks and on the east side of Ellsworth Road. A Pennsylvania woman, known throughout the country for contributing to religious organizations, financed the building materials. Jasper Sossaman, Lee Sossaman, and others provided the labor. The school district also made good use of the building for classes. (Courtesy San Tan Historical Society.)

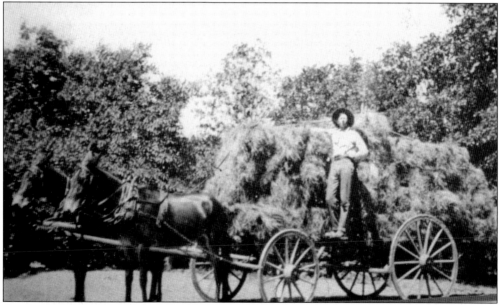

On April 12, 1924, Charlie Brandon stepped from the 10:00 a.m. "Dinky" train with his wife, Lalier; their three small sons; and two trunks with all their belongings. By noon, Brandon was working for Charles Rittenhouse and helping Jasper Sossaman maintain the diesel-powered pumps that sometimes ran day and night. His starting salary was $3.50 per day. Brandon stayed and farmed for 60 years. (Courtesy Frances Brandon Pickett.)

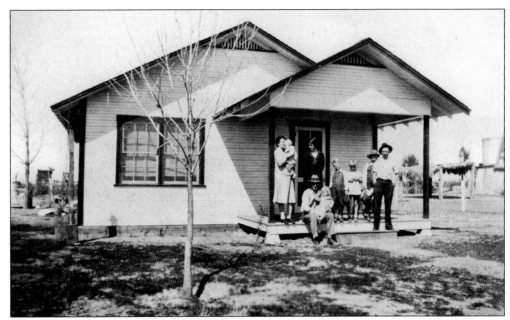

Meals were times for the whole family to get together, and it was no different at the Brandon home. The noontime meal was called dinner, and it was the main feast of the day. A short rest often followed, then work was continued in the fields until sundown; the day ended with chores. This routine was only altered slightly on Sundays. (Courtesy Frances Brandon Pickett.)

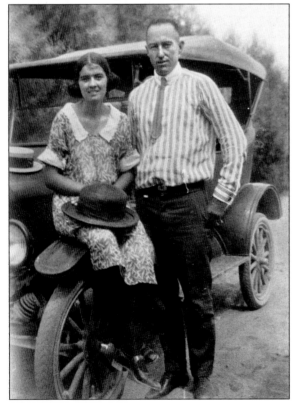

Faith Mather married Jasper "Jap" Sossaman in 1926. Jap was still working for Charles Rittenhouse on Queen Creek Farms, operating and maintaining the diesel engines that powered the pumps used for irrigation. As he worked to build up the family homesteads, he employed this trade, which he had learned in the navy while serving as a mechanic on a minesweeper. (Courtesy Jamie and Sue Sossaman.)

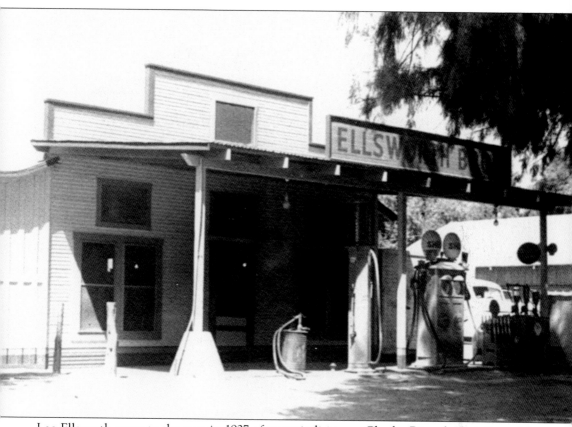

Leo Ellsworth came to the area in 1927 after capitalizing on Charles Rittenhouse's financial missteps. Leo's brother Larence joined him in a farm and general store business. At the time the farming operation began, the area had no roads, so Leo took the lead in their development near the town center. There were also no phones, so Leo paid for the first line. In 1930, Donald joined the others, forming the Ellsworth Brothers partnership. They added a butcher shop and gas pumps. Because no banks were located nearby and transportation was limited, it was nearly impossible to pay the laborers' wages with checks. To solve the problem, Ellsworth Brothers issued scrip money that could be used at the company store. Coins were produced in 5, 10, 25, and 50¢ pieces that had the appearance of silver. One side of the coin was stamped with the amount, while "Ellsworth Bros. Stores" occupied the other side. (Courtesy Delos and Alba Ellsworth.)

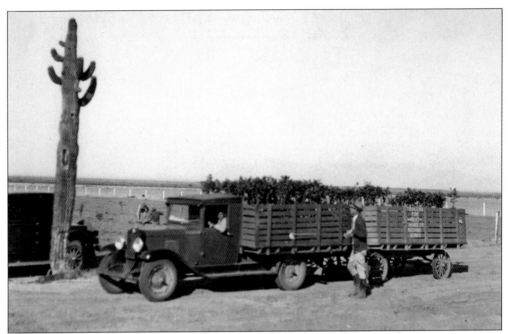

Dr. Alexander J. Chandler had big plans for the development of a farming and investment community at the base of San Tan Mountain, just a few miles west of Rittenhouse. A. J. called the area the Chandler Heights Citrus Tracts and began delivering and planting orange trees in 1928. (Courtesy Virginia Mitchell Minor.)

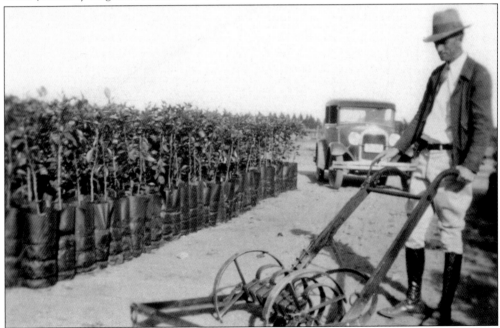

Chandler Heights Citrus assigned grove care contracts to Roy Murdock. A. J. Chandler recommended Murdock to investors, stating, "He has an adequate organization for the complete care and maintenance of groves in a thoroughly high-class manner." Murdock is shown here with a spring-toothed harrow. (Courtesy Roger Nash.)

ARIZONA'S
COMING
CITY

AN ORGANIZATION CREATED FOR THE PURPOSE OF SERVING THOSE WHO SEEK
HAPPY HOMES    GREATER OPPORTUNITIES    LONGER LIFE

AMERICA'S
WINTER
EDEN

**CHANDLER**    KEY CITY OF THE FAMOUS SALT RIVER VALLEY
THE VALLEY OF THE ROOSEVELT DAM    **ARIZONA**

OFFICE OF THE SECRETARY

July 15, 1929.

Mr. Charles K. Simmers,
Southern Pacific Ticket Agent,
Southern Pacific Depot,
Tucson, Arizona.

Dear Mr. Simmers:-

Welcome to Arizona! And when the west bound Californian pulls
into Chandler at 6:45 tomorrow evening, I will be at the station
looking for you. (Mrs. Phillips, my assistant, suggests that I
add that I will be wearing a red gardenia in my off button-hole;
but we don't wear coats here now and I do not know where to get
a gardenia). So, look for a skinny guy with a crooked nose. I
will have a portly gentleman along, Mr. George Cochrane of
Chandler Heights Citrus, Incorporated. Look for a fat blond,
and a skinny brunette, both HE ones.

Now regarding accommodations: I took the bull by the horns and
got Mr. Cochrane to arrange for you to stay at the San Tan Lodge
tomorrow night, which is right in the heart of the citrus tract.
It is a unique establishment, is San Tan Lodge; double canvas
roof summer houses, which, in spite of the heat, enable you to
keep cool. They have a splendid cook out there, too. You could
not get into the San Marcos if you were a billionaire, as it
closes May 1st and does not open again until November 1st. It
is purely a winter hotel.

Looking over mine of June 6th, I find some funny errata, and I
will charge them up to the fact that the particular stenographer
had had a scrap with her sweetie the night before. I find an
error directly chargeable to yours truly---I mean the price
Friend Hinton paid for his 20-acre orange grove, which I stated
as $16,000. This sum was his down payment. My impression is
that his total price was in the vicinity of $33,000. Mr. Cochrane
will give you detailed facts, as he knows Mr. Hinton very well;
but even at that, his 1928-29 season net was somewhere near $17,000,
or approximately 50% return on a total amount invested, which,
when you look it over, might be a lot worse.

The stenographic errors in my letter were chiefly typographical,
and in my postscript I see that the initials of the Virginia
Military Institute were transposed to read "V.I.M.", which as
I recall the character of my virile and vigorous fellow cadets
was not such a bad transposition after all.

Until tomorrow night, (and don't forget to look for a fat he blond
and a skinny **he** brunette) I am

Yours most sincerely,

Addison N. Clark
Secretary.

ANC:RHP

PLEASE ADDRESS ALL COMMUNICATIONS TO THE ASSOCIATION

Many of the new residents to Chandler Heights arrived by train. We may wonder what Charles
Simmers thought when he received a letter, while on his trip, from Addison Clark, Chandler
Improvement Association secretary. Clark wrote, "So, look for a skinny guy with a crooked nose. I
will have a portly gentleman along, Mr. George Cochrane of Chandler Heights Citrus, Incorporated.
Look for a fat blond, and a skinny brunette, both HE ones." (Courtesy Roger Nash.)

According to a letter distributed by the Chandler Improvement Association secretary in the early 1930s, "The fame of southern Arizona's remarkable winter climate has lured thousands of people to migrate hither; and a large percentage of them have done so—and continue to do so, unfortunately—without giving thought to the financial side of such a migration." (Courtesy Roger Nash.)

Within a few years, Charles Simmers was showing success with grapefruit trees on his citrus tract. He had put together a business plan that was financially sound. And as electrical energy became readily available, the pumping of water for irrigation was accomplished more efficiently. Simmers was also known for his grove of date trees. (Courtesy Virginia Mitchell Minor.)

# Chandler Heights Citrus, *Inc.*

ARIZONA'S FINEST CITRUS LAND

Chandler, Arizona

ALEXANDER J. CHANDLER
PRESIDENT

January 24, 1934.

Mr. and Mrs. Chas. K. Simmers,
4023 Monticello Street,
Richmond, Virginia.

Dear Mr. and Mrs. Simmers:

The CHANDLER HEIGHTS CITRUS, INC. has assigned such grove care contracts as they hold, to Mr. Roy Murdock and also recommend him to those of you whose Grove Care Contracts have expired, as he has an adequate organization for the complete care and maintenance of groves in a thoroughly high-class manner.

Mr. Murdock came to our organization five years ago and has the recommendation of the leading citrus authorities of the state. His work has been entirely satisfactory, and as his knowledge of conditions pertaining to the culture of citrus groves at CHANDLER HEIGHTS is of the best, we have no hesitancy in recommending him to you.

Mr. Murdock will contact you in regard to plans for the operation and maintenance of your tract within a few days.

The CHANDLER HEIGHTS CITRUS, INC. will not offer a grove care service after Jan. 31st, 1934, but as above mentioned, are assigning this service to Mr. Murdock where contracts have not expired. He will also enter into planting agreements with any who desires to plant.

Yours very truly,

A.J. Chandler   Pres.

In a letter dated January 24, 1934, and signed by A. J. Chandler, Roy Murdock is also recommended to Charles Simmers for "the complete care and maintenance of groves in a thoroughly high-class manner." (Courtesy Roger Nash.)

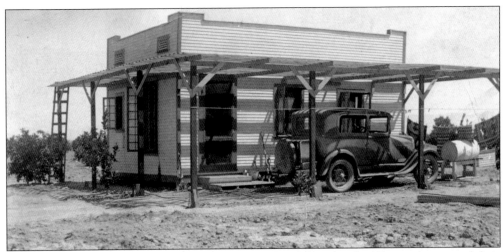

Roger and Tess Binner, with the help of a close friend and their daughter Betty, constructed their first home in Chandler Heights for $1,000. There was no electricity, so lamp oil was kept in a barrel outside. The hand-woven Navajo rugs were hung on a clothesline to air out. Water from Well No. 3 was hauled home in canvas bags slung over the car fender. (Courtesy Roger Nash.)

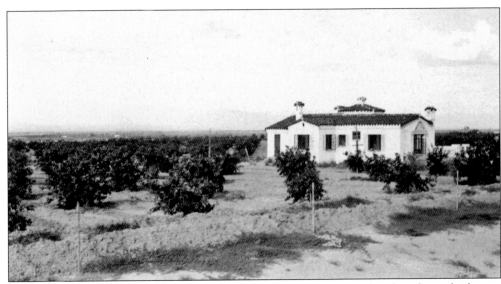

The Dotson home is pictured here. The family made evaporative coolers from boxes built over windows. These coolers consisted of a back panel of wood shavings between chicken wire, and a copper tube with holes to drip water on the panel. By using a fan to draw the air from outside, it would cool as it passed over the wet shavings and into the room. (Courtesy Virginia Mitchell Minor.)

From left to right, Roger Binner, Bill Eckloff, and E. F. Gould visit in front of the Binner home, with mile-a-minute vine growing on a lattice to provide shade. In a manner of speaking, Bill Eckloff came with the Binners' furniture. He had worked for the family in Montana, and when they decided to permanently relocate to their new home in Chandler Heights, he came along and stayed. (Courtesy Roger Nash.)

Families would sleep outside during the summer to get relief from the heat. The smoke from burning old, dry manure and leather was sometime used as a bug repellent. Families also put the bed legs in cans of water or kerosene to keep things from crawling in with them. When it was very hot, they would dip their sheets in water. (Courtesy Barbara Lindsay Smith.)

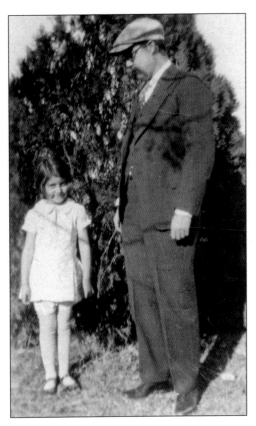

Betty Binner enjoyed spending time with her father but did not like wearing the leggings shown in this photograph. Because they were hot, she would take them off when her father was not watching and hide them in the bushes. At the time, it was fashionable for little girls to wear them, but in Betty's case, it was usually met with resistance. (Courtesy Roger Nash.)

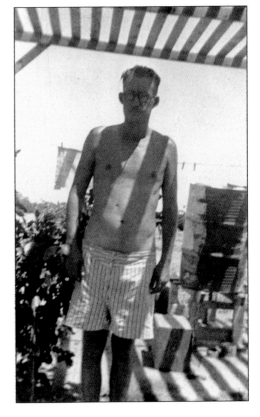

After working all day in the summer heat, Betty's father did not care much about fashion—or modesty either; he wanted to be comfortable. After getting cleaned up, Roger Binner would strip down to his boxers and find respite in the shade. (Courtesy Roger Nash.)

By the mid-1930s, only a few families continued to worship at the Rittenhouse church. With the help and advice of Rev. John Hartman, the congregation acquired a new location in the growing community of Chandler Heights and dragged the building on skids to a site donated by Dr. A. J. Chandler. The church building continues to serve the community today. (Courtesy Roger Nash.)

Ruth Mather was occasionally spotted at the Higley Post Office, where Lawrence H. Sorey had been postmaster since its opening in the back of the general store in 1910. The mail for the surrounding areas was brought to Higley, where it was sorted for delivery. Lawrence's daughter Matilda began serving as the first carrier when a rural route was established in 1915. (Courtesy Jamie and Sue Sossaman.)

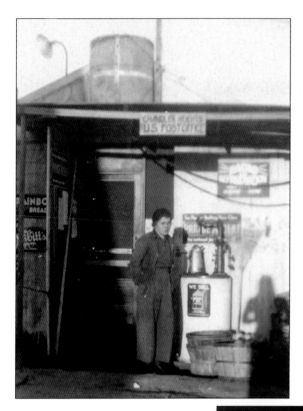

As Chandler Heights continued to grow, the rural mail service from Higley was reportedly not meeting the needs of its residents. On January 24, 1938, John R. Murdock, an Arizona congressman; P. G. Spillsbury, a Washington, D.C., resident and Chandler Heights grove owner; Dr. A. J. Chandler, the founder of Chandler Heights Citrus Tracts; and Tess Binner established the Chandler Heights Post Office. (Courtesy Roger Nash.)

Used mailboxes were purchased from Olberg, a trading post on the Gila River Indian Reservation just south of San Tan Mountain. Tess Binner became the first postmaster. A 3¢ stamp took a letter anywhere in the country. Postcards went for a penny. Tess received a salary based on the daily amount stamped, often less than $1. (Courtesy Roger Nash.)

Tess Binner conducted business in a 4-by-6-foot corner of the Chandler Heights Trading Post, which was located in the garage of the Binner home on South Lime Drive. The trading post stood there until July 1946, when Tess moved it to the corner of San Tan Boulevard and Power Road. It continues to serve the community from that site today. (Courtesy Roger Nash.)

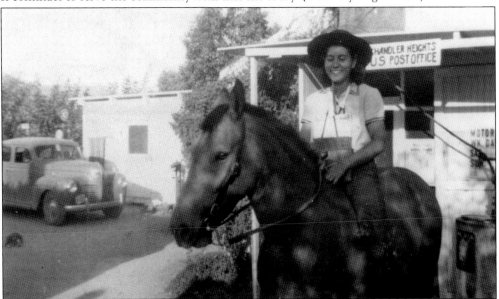

Betty Binner was only 14 years old when she first published the *Chandler Heights Weekly* on July 1, 1939. The newspaper was so successful with residents that it continued for 10 years, with each edition sold for just 3¢ a copy. Betty provided delivery service on horseback. (Courtesy Roger Nash.)

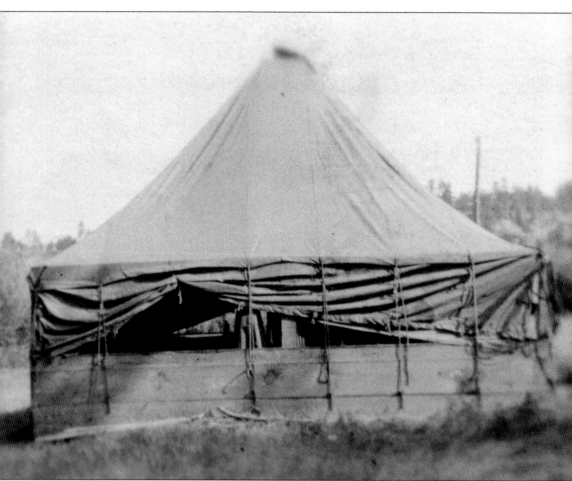

The Depression proved difficult. Families often lived in makeshift wood and canvas homes in the desert while trying to find work on the farms around San Tan Mountain. Families pulled together and worked hard day after day to make ends meet during the Depression years and the years leading up to World War II. Adell Stockam was six when she traveled from Oklahoma to Arizona with her parents and six siblings. She remembers celebrating birthdays along the way, though there were no birthday cakes because her parents were having a hard time just feeding the family of nine. In 1933, her father, Reno, began working as a row boss in the cotton fields. A row boss is a person who walks about the fields, making sure the cotton is picked clean by the workers harvesting by hand. Adell's mother, Ada, picked cotton, as did her father when he was not employed as the row boss. They lived in one of these tent houses. (Courtesy Roger Nash.)

There were two methods of clearing the desert. A tractor pulling steel drags was quick and easy but expensive. Doing the job with what was then referred to as "Oklahoma manpower" was cheaper, albeit painstakingly slow. The term described the men who, working their way West from Oklahoma and other depressed regions, would clear the land for only $1.25 per acre. (Courtesy Delos and Alba Ellsworth.)

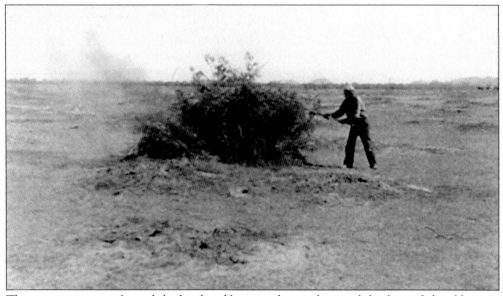

The younger men performed the hard grubbing on the tough-rooted shrubs, and the older men would follow along stacking and burning after them. It was hot, dirty, and physically demanding work. Workers would sometimes save the larger branches to be sold for firewood, thus putting a few extra pennies in their pockets. (Courtesy Delos and Alba Ellsworth.)

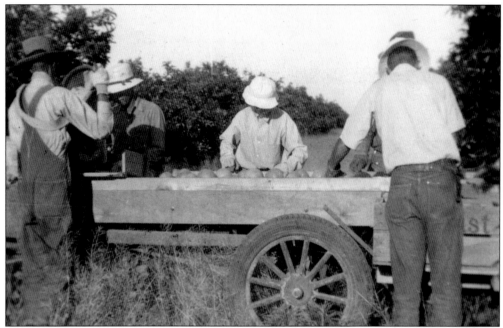

In the years following the Mexican Revolution—the 1920s—families continued to migrate to Arizona to seek new opportunities for a better life. Although some were educated, most were not and therefore had to work in the fields and groves of the already established families. (Courtesy Roger Nash.)

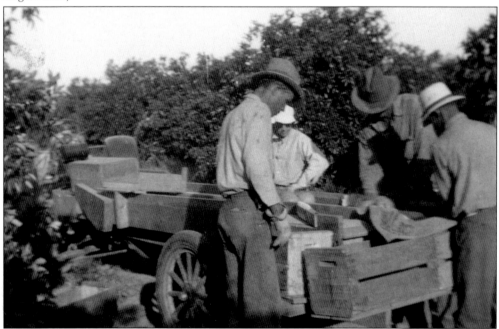

Those who migrated to Arizona from Mexico were poor, underprivileged, and sometimes victimized by prejudice. Despite being isolated by language, culture, and occupational barriers, these hardworking families contributed significantly to the rich heritage of the communities and have played a vital role in the development of the area. (Courtesy Roger Nash.)

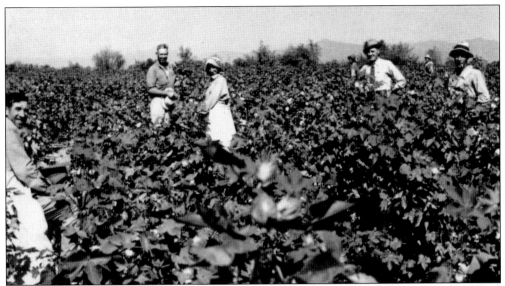

The communities around San Tan Mountain take pride in knowing that they are still home to many Mexican American families that traveled here in the 1930s. The Aldecoa, Trujillo, and Valenzuela families first worked as irrigators in the vegetable and cotton fields. They established long-lasting relationships with farm owners and, in some cases, started businesses of their own. (Courtesy San Tan Historical Society.)

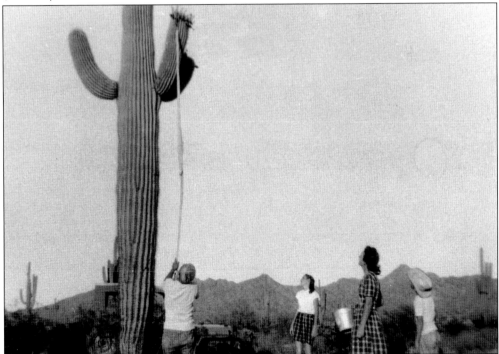

Residents often depended on local desert plants, such as the saguaro cactus in late May and early June, for fruit. Using a spine from the saguaro, family members would take turns knocking the fruit to the ground. The fruit would first be scrubbed to remove spines, then boiled and strained to produce the nectar used in making jelly. (Courtesy Barbara Lindsay Smith.)

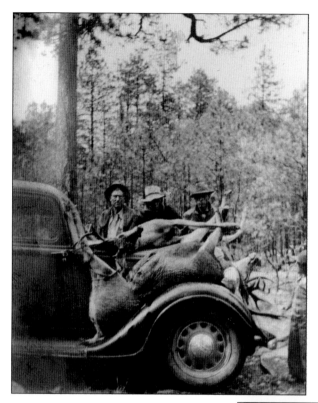

To add to the produce and fruit available locally, men made hunting trips to the high country. These were often highly celebrated community events because of the fresh meat that would become available. Lee Sossaman, along with neighbors and friends like Coy Beasley, would help coordinate the annual hunting trips during the Depression years. (Courtesy Jamie and Sue Sossaman.)

Jamie Sossaman, who participated in the hunts as a young man, was often caught admiring the elk while his uncle Lee and friends looked on. Under the headline "Three Elk, Four Deer, Bagged by Huntsmen," one newspaper article read, "A hunting party, including Jasper Sossaman, Lee Sossaman, of Rittenhouse, C. I. Martin, Sacaton, and Zeb Pearce, Mesa, returned last week-end with a prize bag of three elk and four deer." (Courtesy Jamie and Sue Sossaman.)

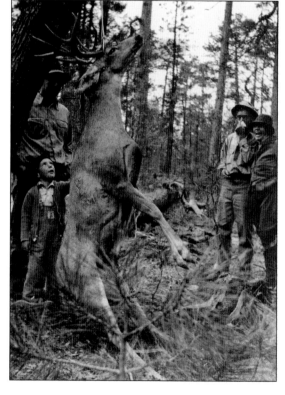

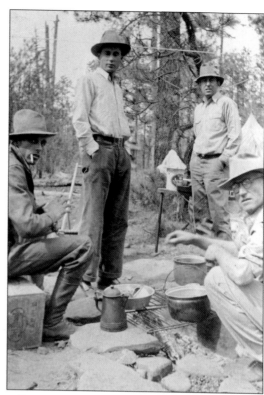

Pictured from left to right, Judge Coy Beasley, Leslie Sossaman, J. H. ("Jap") Sossaman, and Lee Sossaman relax around a campfire after the hunt. The newspaper continued by reporting, "The hunters bagged the game in the region of the Mogollon Rim, near Pine. The meat weighed approximately 2500 pounds, the largest of the elk tipping the scales at 550 pounds. All of the bucks were about the same size, weighing about 185 pounds each. Earlier in the season, Jasper Sossaman was fortunate in bagging a huge bear." This was a time when people of the community came together to put food on the table. Money was scarce, so those who had extra shared with others in the communities of Rittenhouse, Higley, and Chandler Heights. Below is Jamie Sossaman. (Courtesy Jamie and Sue Sossaman.)

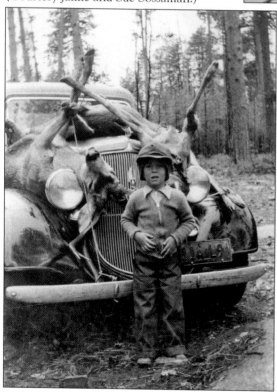

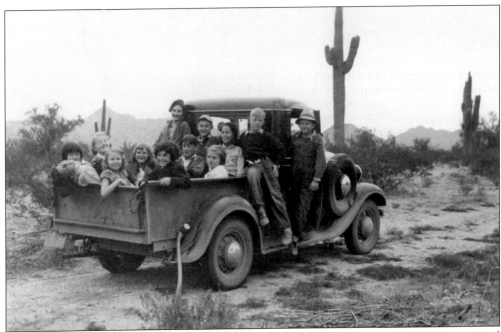

Betty Binner's friends—12 for her 12th birthday—help her celebrate with a desert outing and picnic. The excursion was held during Christmas break, before her February birthday, so that everyone was available to attend. Once school started, some of these kids had jobs that kept them busy on weekends. (Courtesy Roger Nash.)

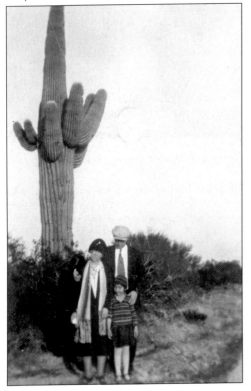

The surrounding desert provided the setting for many family events, including photograph opportunities in front of a saguaro cactus that had been aging gracefully for years. Tess (left), Roger, and Betty Binner, like many of the residents of Chandler Heights, made regular trips to enjoy the desert, posing occasionally for family portraits. (Courtesy Roger Nash.)

From left to right, Tess and Betty Binner are pictured here with Louise and Jellum "Jelly" Brackstead. Louise, Tess's sister, married Jelly, a railroad engineer out of Livingston, Montana. Roger Binner and Jelly would often get into heated but friendly debates about who was responsible for winning World War I. Jelly had served as a marine, while Roger had been in the army's 101st Engineers. (Courtesy Roger Nash.)

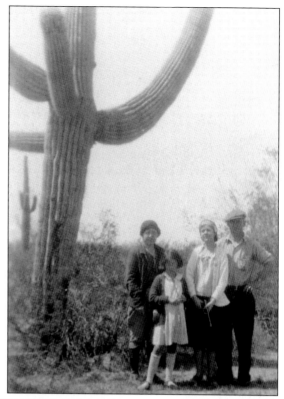

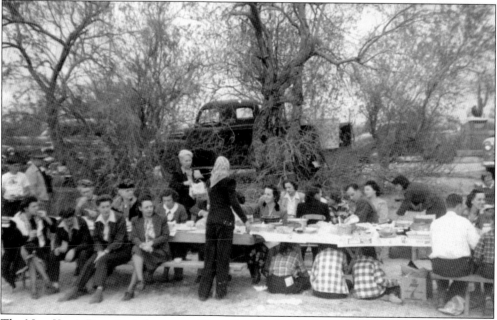

The New Year's Day picnic became a Chandler Heights tradition that was honored for over 50 years. First organized on January 1, 1930, and hosted by Roger and Tess Binner, it was held under a decorated arbor at Well No. 1, located at the edge of the Citrus Tract's demonstration grove. (Courtesy Virginia Mitchell Minor.)

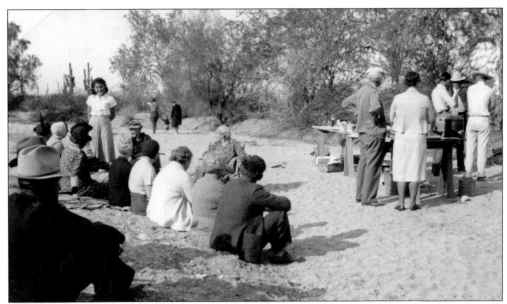

When Chandler Heights held its annual picnic to celebrate the new year, everyone, including Dr. A. J. Chandler, turned out for the event. He often sported a golfing cap while talking with local residents. As the years progressed, the picnic location shifted to other favorite local sites. Weather was the only thing to dampen the spirit of the participants. (Courtesy Roger Nash.)

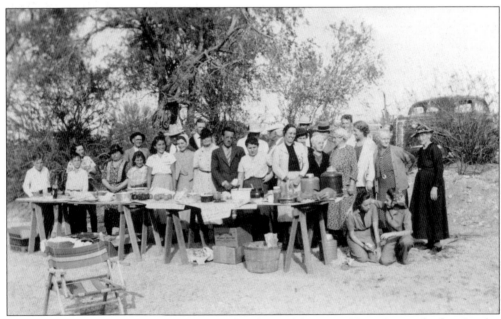

Planned through word of mouth, the picnic also changed from New Year's Day to the first Sunday after New Year's to avoid conflicts with parades and football games. Those fortunate enough to live in the community during these years still have many fond memories from the annual gatherings. Friendships and relationships were founded that have survived the tests of time. (Courtesy Roger Nash.)

The Ellsworth brothers' holdings continued to grow to nearly 20,000 acres of owned and leased land. With the aid of a team of good foremen, they operated one of the state's largest and most successful diversified ranching projects. Their operation soon consisted of raising cotton and large acreages of vegetables, sugar beets, cattle, sheep, hogs, and a dairy herd. (Courtesy Max and Carolyn Ellsworth Schnepf.)

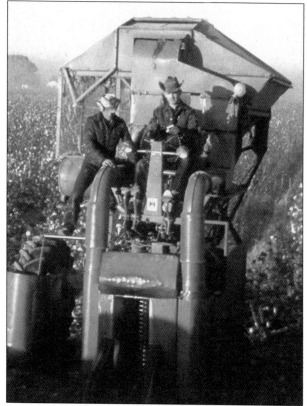

As their farming operation expanded, the Ellsworth brothers offered their sisters an opportunity to purchase land for farming and homes. During the 1930s and early 1940s, five of their six sisters and their families moved to the area: Grace Jones, Blanche Nelson, Remola Pew, Lona Cloud, and Zelda Freestone. Friends were also invited to own land and farms in the area. (Courtesy Max and Carolyn Ellsworth Schnepf.)

The Sossamans built new homes in the early 1930s. Neighbor Florence McEntire recalled her pioneer days as happy ones, with the exception of housecleaning. When asked about the worst, she answered, "Not the hard work, nor the heat, but the horrible dust storms. The housecleaning that always followed was such a job, for it got into everything." (Courtesy Jamie and Sue Sossaman.)

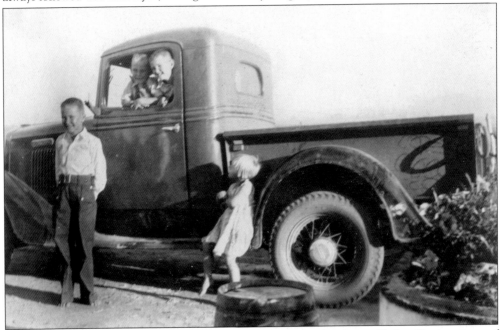

Shown from left to right, Alvin, Lorin, Leo, and Joyce Reber lived near Higley. During times of rationing, the gasman would come out to the farm to fill the tractor drums, adding a dye to the gas. If family members used the gas from the drums in their cars, the color would show up in the carburetor and they would be considered unpatriotic. (Courtesy Ed and Joyce Nevitt.)

Before tractors were available, early pioneer Gid Duncan provided many of the mule teams used for clearing the desert for settlers. By 1940, he was well established in the community as a landowner, for he would sometimes accept land as payment. (Courtesy Frances Brandon Pickett.)

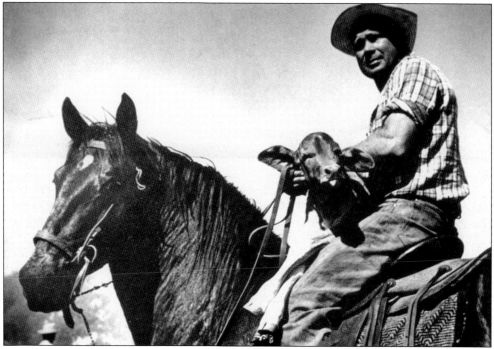

The Powers' 13 children had a three-mile walk to school. Some days, a loose donkey could be cornered along the way, but in later years, the children were provided with horses. Even when they were out of school and farming on their own, the Power boys were still spending many hours of their day on a horse. (Courtesy San Tan Historical Society.)

The water tank at the IC Ranch was not only a welcome place to cool sun-baked toes on a hot day, but also the centerpiece for many activities. The ranch consisted of a windmill, the water tank, a number of cutting pens, and a couple of small shacks for tack and the resident cowboy. Named for one of the Ellsworth family brands, the IC was the primary watering and shipping spot for the cattle roaming the cross-fenced desert. Local folklore states that a mail route also passed by this ranch, with stages stopping for shade and water. The watering trough attracted wild horses to the pens at night. In the early 1930s, a few ambitious young cowhands attempted to catch a white stud with a quick close of the gate. The horse was known to have broken many fences after discovering the late-night trap. This of course resulted in some harsh words from Leo Ellsworth, followed by some rapid fence mending by the kids responsible. (Courtesy Frances Brandon Pickett.)

# Two

# Bringing Life to the Desert

The desert around San Tan Mountain received a lot of attention as it began to develop. A reporter for the *Chandler Arizonan Tribune* gave his first impression of the 1,000-acre Queen Creek Farms in a 1920 article, writing the following:

> This is not the visionary dream of an idealist, but a fact that is rapidly being proven by the experiences of hardy pioneers who have the courage of their convictions. . . . We then traversed mile upon mile of what appeared to be hopeless desert. An almost unending stretch of sagebrush, greasewood and other desert shrubs stretched as far in every direction as the eye could see, and when an end to this monotonous scenery appeared beyond reach, our eyes were suddenly surprised by something green in the distance.

For those willing to take a financial risk up front, state land could be purchased for $12 an acre and up, depending on its potential. Homesteads were also another option along a corridor that paralleled present-day Power, Sossaman, and Hawes Roads. Desert conditions were harsh and relentless, even with plentiful water for irrigation. Cattle grazed on the open range desert, wandering into the fields during the hot summers. They would get so thirsty that no fence would keep them out and they would charge anyone trying to hold them back from water.

Rabbits plagued the farmers, coming in off the desert after sundown to feed on the crops. Young men made sport of this, driving through the desert and along fence lines; they would shoot at the rabbits while sitting on the front fenders of their cars.

Snakes were also a common aggravation. Johnnie Raye Clegg recalled one trip home with her husband, Dike, in the early 1940s. The two were riding in their pickup, and Johnnie was especially uncomfortable because her feet were resting on a big wooden box. When she asked Dike about the box, he told her it was only dynamite and "not to worry," because "the blasting caps are in the glove box." Dynamite was used to clear out nests of snakes.

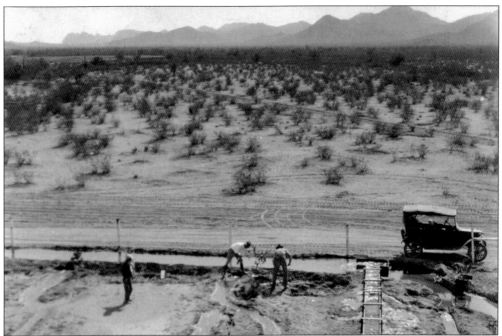

During the boom year of 1919, a number of far-seeing individuals began major projects of desert reclamation. Charles H. Rittenhouse formed the Queen Creek Farms Company along the Arizona Eastern Railroad southeast of Higley. At the time, only a few acres were already under a high state of cultivation and irrigation by local homesteaders in the area. (Courtesy Virginia Mitchell Minor.)

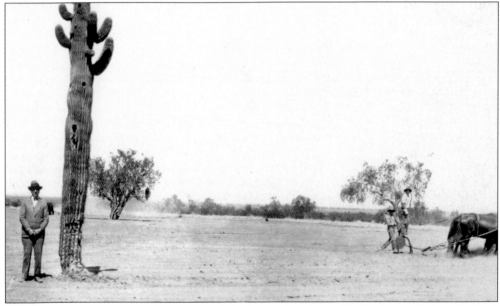

Snapshots were sometimes taken to record the farmers' optimism for the future, before the hard work of clearing the desert was too far along. The index of prices received by farmers had begun an upward trend, and many were confident that this would continue for the next decade. (Courtesy Virginia Mitchell Minor.)

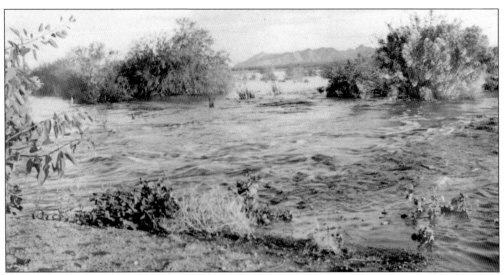

Authorities planned 20 pumping plants to tap the underground water table near Rittenhouse Station. The other source of water was Queen Creek, a stream that was, under existing conditions, impossible to rely on or control. At intervals, the stream overflowed its banks in destructive floods while remaining dry the rest of the time. (Courtesy Roger Nash.)

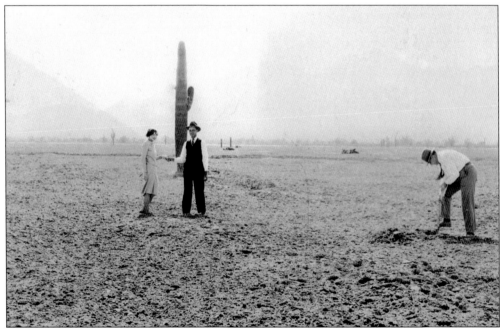

The land held promise, although it may have been hard to recognize at first. Toward the end of the 1920s, Dr. Chandler, C. A. Baldwin, and others formed Chandler Heights Citrus, Inc., with a capital of $5 million. The avowed purposes were to reclaim a 5,000-acre tract 13 miles southeast of Chandler, to prepare the land for citrus cultivation, and to colonize the area. (Courtesy Virginia Mitchell Minor.)

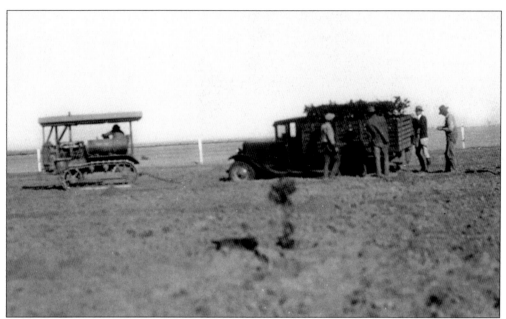

A. J. Chandler started bringing in orange trees by the truckload once the wells and pumping stations were in place and the irrigation ditches ready. Roads were not much more than dirt paths in many areas, and the trucks would often get bogged down with their heavy loads. (Courtesy Virginia Mitchell Minor.)

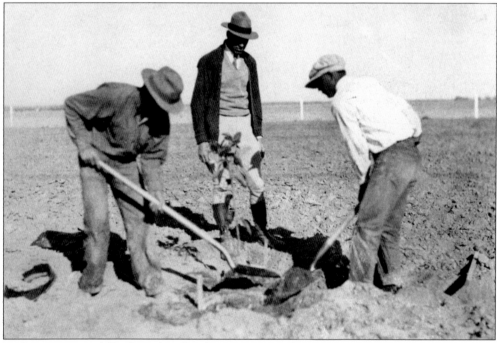

Each tree was carefully planted under close supervision for ongoing care. Citrus cultivation was not new to the Salt River Valley, but it had never been a major pursuit until now. The area of Chandler Heights was known for the absence of a killing frost combined with warm Arizona sunshine. (Courtesy Virginia Mitchell Minor.)

44

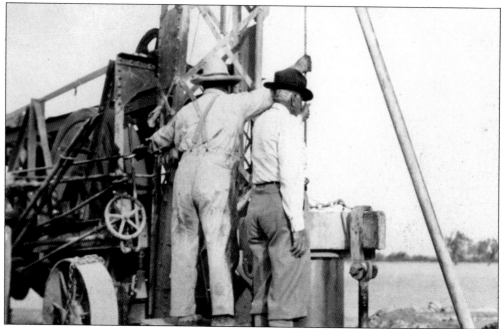

The Chandler Heights Citrus Irrigation District was formed in 1929, and water was supplied by a number of wells. The region was well situated for the growth of citrus, being in a thermal belt where smudging was reported to be unnecessary. Within a short time, many investors had started their groves of orange and grapefruit trees. (Courtesy Virginia Mitchell Minor.)

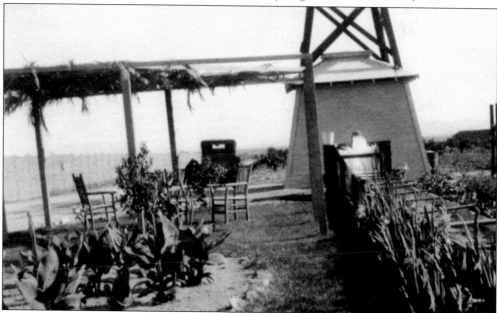

This 1931 photograph of Well No. 1 in Chandler Heights shows the pump house. The derrick above the pump house would be used for attaching a winch. The rigging could then lift and maneuver heavy equipment for maintenance of the diesel-powered engines that powered the pumps. These wells required constant attention and care to produce a steady stream of 1,900 gallons of water per minute. (Courtesy Virginia Mitchell Minor.)

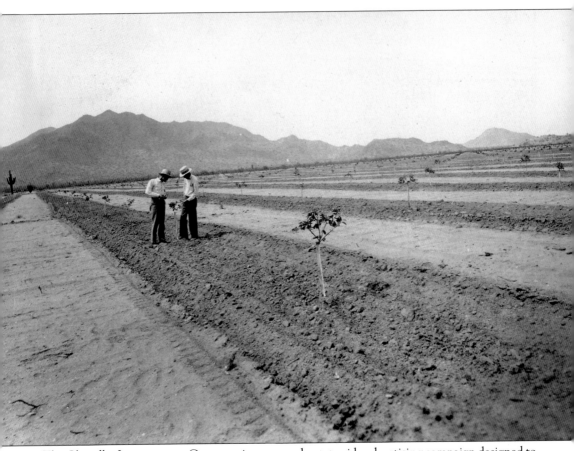

The Chandler Improvement Company inaugurated a statewide advertising campaign designed to attract more investors to the new citrus area in and near Chandler Heights. Economic conditions in the valley were at their best since early 1920. The optimism paralleled that of 1919. The stock market crash that was to occur later in the year—a financial catastrophe that devastated our country—could not have been imagined. According to an early-1929 Chandler Heights Citrus Tract bulletin, "The demand for citrus fruits that already has taken place and is still in process, coupled with the fact that oranges and grapefruit grown in Southern Arizona have substantially proved that they can and do command premium prices in the market, makes investment in Southern Arizona citrus-growing land today probably the outstanding 'gilt-edged' opportunity in the entire realty investment field." (Courtesy Virginia Mitchell Minor.)

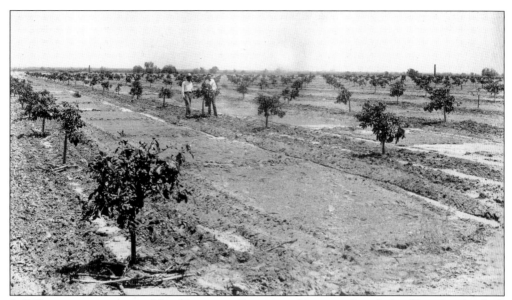

L. F. Youngs, an executive of the Aluminum Company of America, bought land based on his faith and respect of Dr. Chandler, stating, "I plan to build a home on my own tract, and spend winter months out here in this perfect climate, enjoying my own ranch and the magnificent view of the whole Salt River Valley from here." (Courtesy Virginia Mitchell Minor.)

Photograph postcards, like this one received by Roger Binner in 1930, were sent to all the new owners of citrus property in Chandler Heights by Dr. A. J. Chandler and the Chandler Improvement Company. This was done to prove that the investment property had been planted and was being managed as agreed upon in the original contract. (Courtesy Roger Nash.)

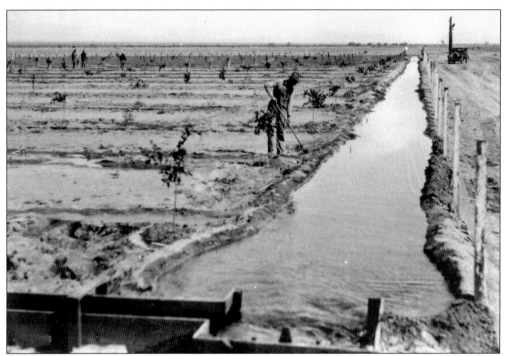

The early dirt irrigation ditches required constant attention and repair. A break could be disastrous. The success of any agricultural endeavor in the desert depended on consistent and reliable irrigation. Engineers for Chandler Heights reported that their water source was in deep-lying gravels, laid down by the Gila River eight miles to the south, on the other side of the San Tan Mountain range. (Courtesy Virginia Mitchell Minor.)

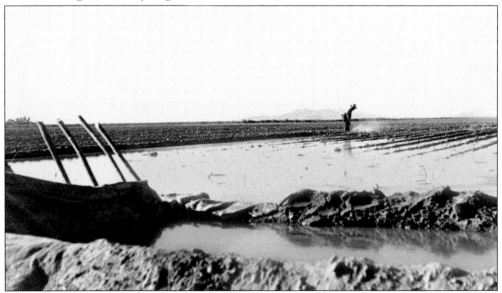

Controlling the water around a low spot demanded much experience and attention for long hours at a time. According to Paul Jones, a photographer who chronicled the development of the area in the late 1930s, the irrigators were considered skilled workers and would often get paid more—and possibly feel a little superior to the average farmhand. (Courtesy Delos and Alba Ellsworth.)

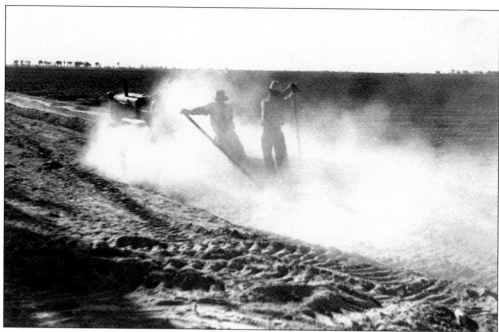

Building an irrigation ditch was dirty and physically demanding work, but it took a young and clean channel to handle the volume of water needed in the desert. The head ditch was frequently relocated by a crew with special equipment to prevent erosion and excessive weed growth. (Courtesy Delos and Alba Ellsworth.)

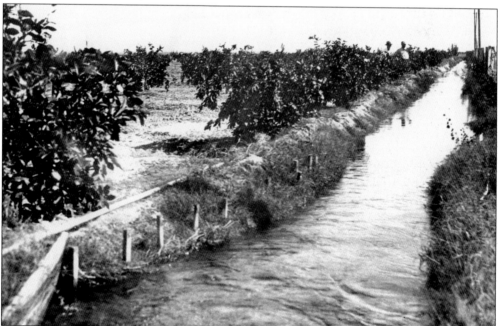

Wooden posts, branches, and straw were secured along the banks to keep the soil from eroding into the flow of water and washing into the fields in the years before cement-lined ditches. Irrigating on such an extensive scale, as was needed for these fields, called for experienced hands. (Courtesy Virginia Mitchell Minor.)

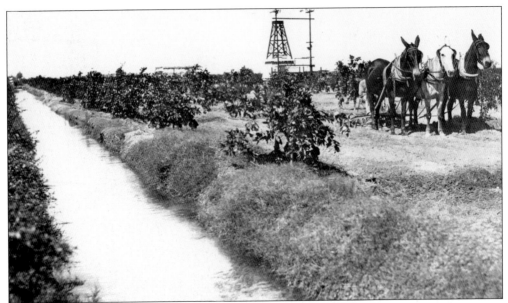

The Chandler Improvement Company advertised, "Chandler's new citrus land development, at the Chandler Heights suburb centering fifteen miles southwest at the foot of the San Tan Range, offered to investors in the profitable orange and grapefruit business the most attractive potential returns on their money to be found today in any of the four citrus-growing states of the Union." (Courtesy Virginia Mitchell Minor.)

According to a Chandler Improvement Company bulletin, "The new Chandler Heights citrus tract will more than meet every acid test that can be applied to citrus land. Lying along the new Hunt highway from Phoenix and Chandler to Tucson, via Florence, the tract stretches for seven miles east and west, gently sloping . . . at the foot of the sheltering picturesque San Tan mountain range." (Courtesy Virginia Mitchell Minor.)

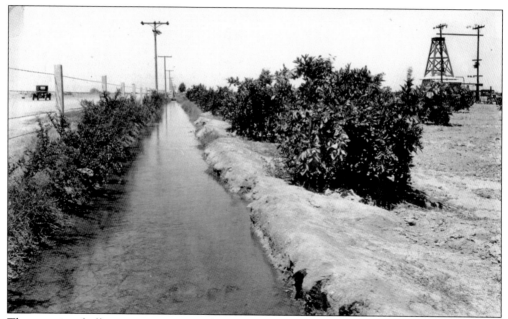

The company bulletin went on to say the following about Chandler Heights: "Its distance from Chandler is thirteen miles, over excellent highway all the way, part of it being cement-paved. At the mouth of the pass between San Tan peak and Goldmine Mountain, the two highest peaks of the protecting range, it is two miles in width. The average north-south width is approximately a mile." (Courtesy Virginia Mitchell Minor.)

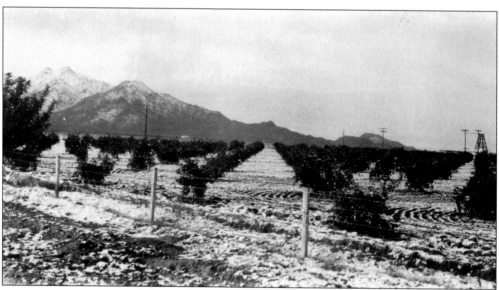

Snow fell occasionally, despite the claim that Chandler Heights provided "a home in the incomparable climate of Southern Arizona, with freedom from snow, slush, blizzard, hurricanes, tornadoes, floods, earthquakes, and droughts." The Chandler Improvement Company bulletin continued, "The abounding health that Southern Arizona's climate brings, and an all-the-year-around out-of-doors life [is] the sort of life that adds decades to the ordinary human span of existence." (Courtesy Virginia Mitchell Minor.)

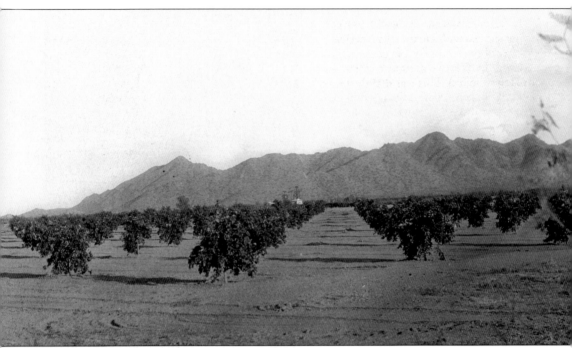

The Arizona Citrus Growers met in Phoenix and released the following early in 1929: "Arizona's citrus area is but a drop in the bucket of the total in the United States, being less than one per cent. There are immediate prospects of an increase here which will probably total 15,000 acres in the next few years. Of this, the probabilities are that about 10,000 will be grapefruit and 5,000 oranges." Alexander J. Chandler, Chandler Improvement Company president, signed his name to claims of "pure, plentiful water-supply—Freedom from the insect and scale pests that beset citrus growers in the other citrus States of the Union—Convenient proximity to the shops and schools of the model city of Chandler, and to the metropolitan city of Phoenix and the University of Tucson—Three hundred days of vitalizing sunshine, by U.S. Weather Bureau record, per year." (Courtesy Roger Nash.)

Betty Binner's mother was well known for her success with citrus. As an active member of the Chandler Heights Citrus Growers, Tess produced some of the finest citrus to be found. This was mainly due to her skills as a grower and the good supply of water from the five irrigation wells belonging to the association. (Courtesy Roger Nash.)

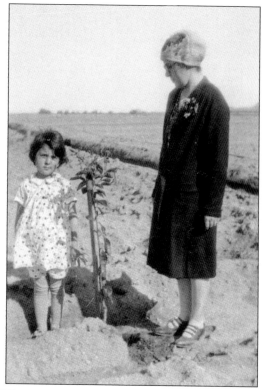

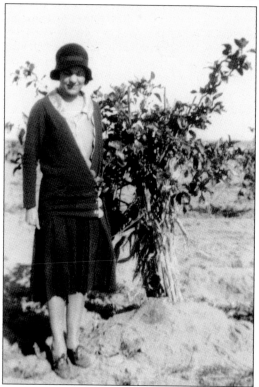

Tess Binner wrapped newly planted citrus trees with cornhusks to keep them from freezing. One year at the Arizona State Fair, she took first prize on Robertson navel oranges, first on Washington navel oranges, first on Persian limes, first on ruby red grapefruit, first on Mexican limes, second on pink seedless grapefruit, and second on Eureka lemons. (Courtesy Roger Nash.)

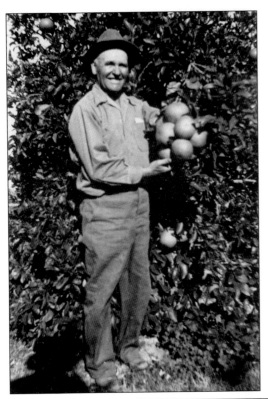

Alvin Samuel "Pop" Reber farmed in the Higley area and was also quite successful with grapefruit, sometimes getting 10 grapefruit on one cluster. A grove in 1929 could yield an average of 12 boxes per tree. This, at 90 trees per acre for $1.40 a box, brought in a very satisfactory return of $1,512 an acre. (Courtesy Ed and Joyce Nevitt.)

Statistics released by the U.S. Department of Agriculture in February 1929, covering the grapefruit industry for the period of 1917 to 1926, indicated a 500-percent increase in grapefruit production at the time. There were 3,148 carloads of grapefruit raised in the country in 1918 and 18,000 in 1926. (Courtesy Virginia Mitchell Minor.)

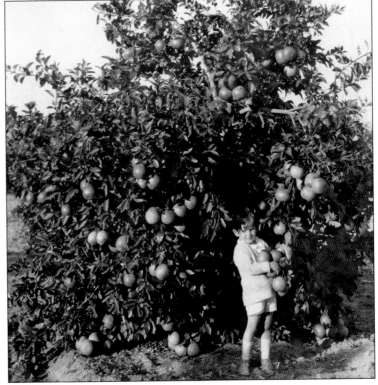

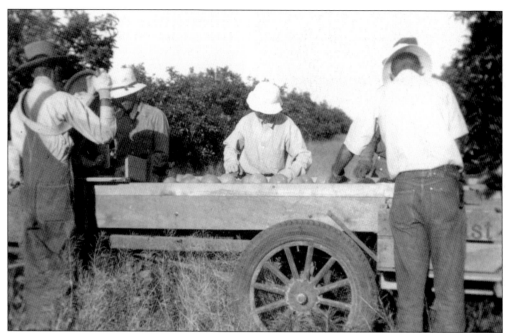

Tess Binner took photographs of these migrant workers in 1937 but did not develop them until the following year, when she had enough egg money. Fruit was packed in the groves just after being picked, before a packinghouse was built in Chandler Heights. The wooden boxes were then taken to the Serape Railroad Siding south of Chandler Heights Road, just east of Arizona Avenue. (Courtesy Roger Nash.)

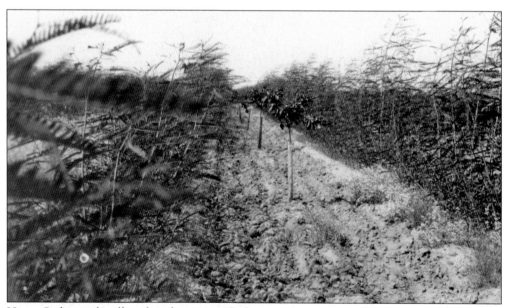

Hemp Sesbania, locally referred to just as Sesbania, is a native weed that grows wild along the Colorado River bottomlands in western Arizona. Sometimes brought to the area and grown as a green manure crop in the citrus orchards, it would often spread to the irrigation ditches and roadsides. (Courtesy Virginia Mitchell Minor.)

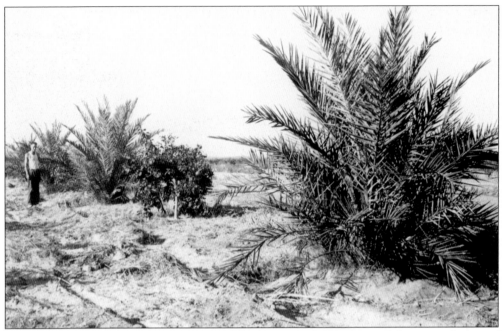

This farmer's tract of date trees was taking full advantage of irrigation and the warm climate of 1932. It was common practice to interplant grapefruit and date trees. Growers believed it beneficial for the feet of the date trees to be shaded by the citrus. The dates, when mature, would then shade the crowns of the citrus. (Courtesy Virginia Mitchell Minor.)

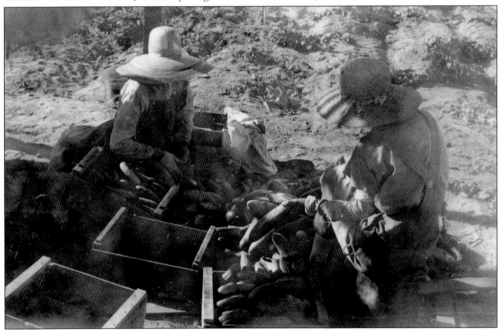

Families that lived in an agricultural area like Chandler Heights had some very obvious advantages. These farms could—and did—grow more than just citrus. A variety of produce was cultivated on the properties and in the family gardens, such as sweet potatoes, lettuce, tomatoes, melons, and these fresh cucumbers. (Courtesy Virginia Mitchell Minor.)

During the 1930s in the Rittenhouse and Higley area, farmers depended heavily on laborers. Living conditions were sparse for the workers, and sun-dried mud adobe apartment-like structures with dirt floors were common. Frances Brandon remembers showing them to a visiting cousin and telling her that the end room of this complex could be locked when someone got too rowdy. (Courtesy Frances Brandon Pickett.)

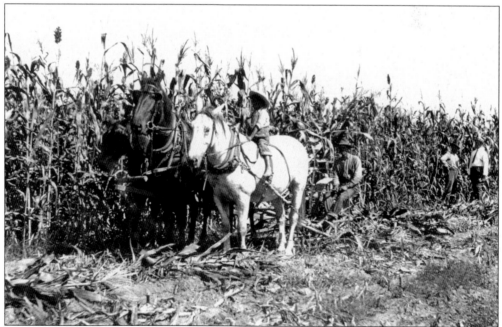

Mules were often used to pull the cumbersome farm implements prior to the availability of tractors. In this 1930 photograph, grain sorghum is being harvested as an alternative feed to corn. The crop was higher in protein and lower in fat content, and the entire plant could be used for silage. (Courtesy Virginia Mitchell Minor.)

It may have been a mule that coined the phrase "take a load off, and sit a spell." It has been said that the mule has more eccentricities and undeniable virtues than any other domestic animal. A noontime rest was needed during longs days in the fields, even with the mules' ability to withstand hardship in a hot and dry climate. (Courtesy Frances Brandon Pickett.)

Growing up in the area, Emory Shahan liked to ride into the mountains to rope wild horses. Some say there is a horse thief in every family, and Emory once admitted that he was the one in his. When a tree is not available, an old picket fence across a couple of uprights can provide makeshift shade. (Courtesy Bernadette Heath.)

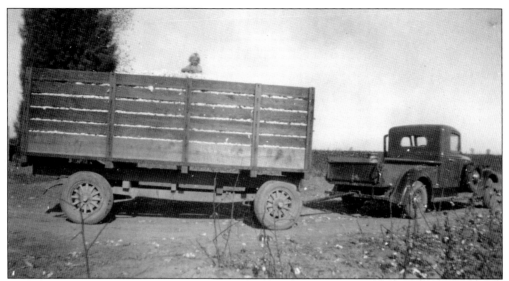

Cotton wagons were built on the chassis of old used trucks. Each farmer painted his wagons a unique color, so that they could be easily spotted when everyone lined up at the gin. One local farmer shared that he preferred short staple cotton; the long staple gin was too far away, but several gins for short staple were located nearby. (Courtesy Ed and Joyce Nevitt.)

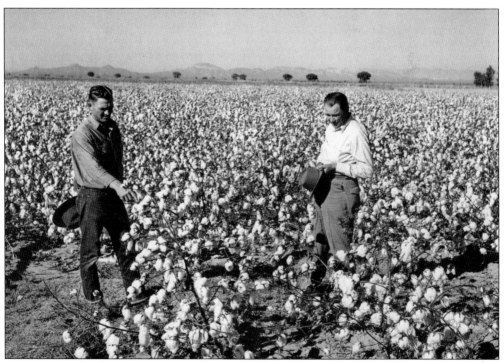

By the late 1940s, farmers were producing good crops of cotton, often because of the dedication of their Ag Chemical representative. Norman Golder would often visit the fields to ensure that his customers were happy. This local chemical company representative worked closely with the farmers to check fields twice a week if needed, and together they would decide on what chemicals to use and when. (Courtesy San Tan Historical Society.)

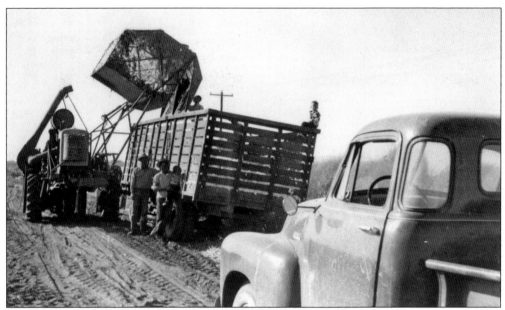

Cotton growers would constantly manipulate watering schedules to fit specific needs. In the late 1960s, Charlie Brandon demonstrated yields that testified to the value of close plant management; consistently producing yields in excess of 3 bales per acre, hitting a high of 4.54 bales in 1968. (Courtesy Newell and Katherine Barney.)

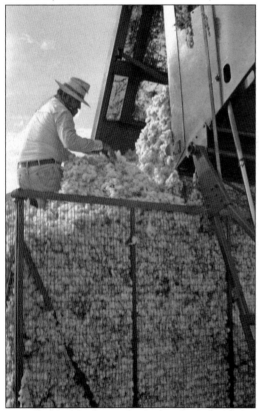

The first cotton gin was located along the railroad tracks at Ellsworth Road. The Ellsworth brothers built a second on the northeast corner of Ellsworth and Ocotillo Roads. After the Depression, cotton became the staple crop for many of the farmers in the area. (Courtesy Bernadette Heath.)

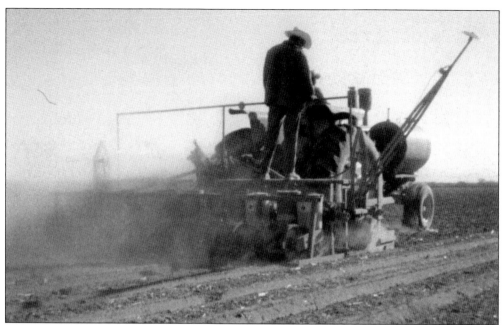

Cotton was planted toward the end of March. The first irrigation would be applied in May, with watering again at first bloom. Farmers then watched closely until the plant started to load up with bolls. If it failed to load up properly, most farmers would hold the plant back so that it would not grow excessively. (Courtesy Mark Schnepf.)

Gene Hall could at times stand in the shadow of his cotton plants. The only fixed part of the irrigation program is that a farmer starts out the season with a full root zone. Once the plant is in the fruiting habit, it is easier to control growth. If a plant is set with three to five bolls before mid-July, it can keep fruiting right through the month. (Courtesy Barbara Peacock.)

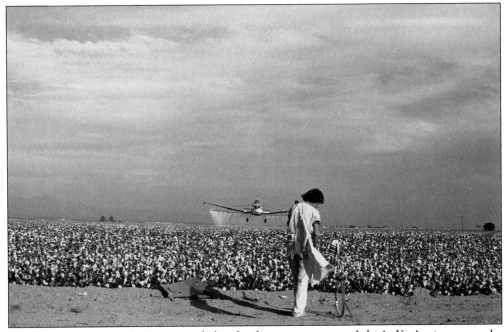

L. T. Jarnigan once said, "Some people buy books to grow cotton. I don't. You've just got to be there every day to see what your crop needs and be a good farmer." Cotton farming was a gamble and a challenge, and according to Jarnigan, the best time was when he sold the bales and got paid for the year. (Courtesy Bernadette Heath.)

Many remember the sharp burrs on cotton bolls. When picking by hand, it was wise to wear gloves with the fingertips cut out. Barbara Hall picked cotton for spending money—the amount she earned was based on the weight shown on this field scale. There was always someone nearby to check the bag, ensuring that Barbara had not accidentally slipped in a rock or two. (Courtesy Barbara Peacock.)

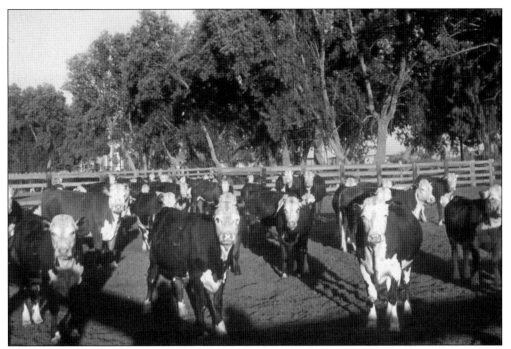

J. O. Combs balanced cotton farming with cattle raising. If he had a poor crop, he could market the cattle to bolster the family income. If he had a good cotton year, he could hold onto his cattle. That way, the family would not be pushed into a backbreaking tax bracket. "The government can't tax cash that's roaming around on the hoof," Combs remarked. (Courtesy Max and Carolyn Ellsworth Schnepf.)

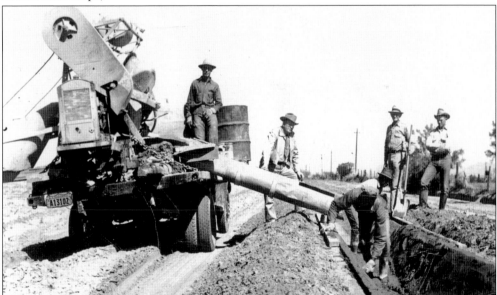

Combs had what was considered one of the most diversified farming operations in the area. By the late 1950s, the ranch included 23 miles of roads and ditches, four pumps bringing up irrigation water from depths between 610 and 705 feet, barns, storage bins, and a feed mill. By this time, cement was being applied to the irrigation ditches. (Courtesy San Tan Historical Society.)

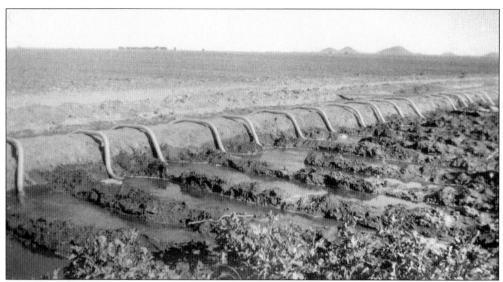

Farmers invented a number of improvements for irrigation as years progressed, such as these bent, lightweight aluminum tubes designed by Ray Schnepf about 1943. These tubes were much lighter than the rubber siphon tubes used at the time. A skilled irrigator could drop them in place and start the flow of water into the field on the run. Plastic tubes are used today. (Courtesy Mark Schnepf.)

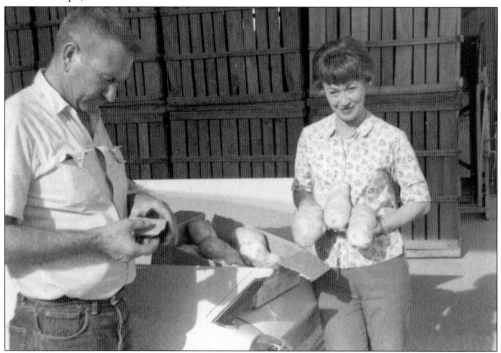

Arizona's 1956 potato crop was the best in years, according to a Farm Bureau report. Queen Creek's soil, combined with well-managed irrigation and fertilization, ensured a great potato-growing area. Ray and Thora Schnepf were producing these jumbo potatoes by the mid-1960s. Too large to go through the potato chip slicer, they were instead sold to a company that made French fries. (Courtesy Mark Schnepf.)

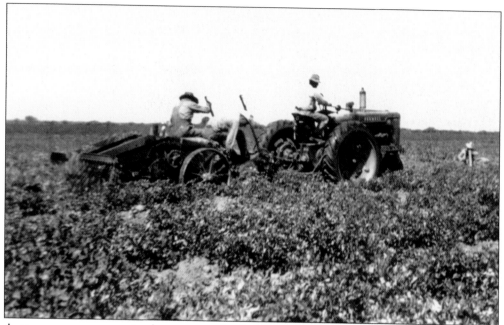

A common crop grown in the area was the Red Pontiac—a ruddy-skinned white potato. Bob Brooks was raised on a ranch but admitted that as a kid he had not paid much attention to the details. So when he started farming, Brooks would go out each morning to see what his neighbors Roy Wales, Lee Hildebrandt, and Walter Gantzel were doing. The strategy paid off. (Courtesy San Tan Historical Society.)

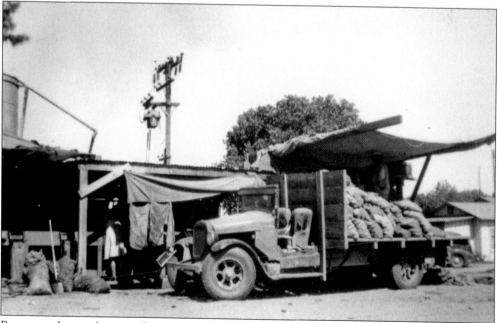

Potatoes take nearly as much water as cotton, but because they are a shallow-rooted plant, water must be applied carefully. Condition of the crop and soil, not the calendar, determines when it is time to irrigate. Potatoes were dug, picked up, and sacked in the field. The sacks were then loaded onto trucks for transportation to the grading shed. (Courtesy San Tan Historical Society.)

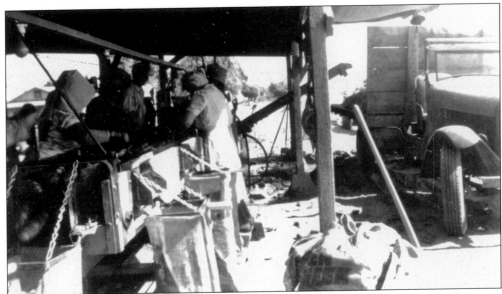

The sacks were emptied and the potatoes washed, graded, and resacked at the shed. They were then weighed and loaded into refrigerator cars. Chipping potatoes represented 25 percent or more of many farmers' gross income. Ordinarily, potato yields in the Salt River Valley averaged around 250 bags per acre and graded out about 65 percent U.S. No. 1. (Courtesy Jamie and Sue Sossaman.)

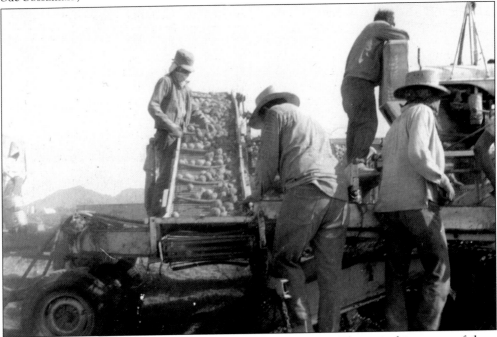

Ernie Hawes designed and constructed three potato harvesters. These machines, two of them tractor-drawn and one self-propelled, could harvest up to eight or nine acres of potatoes every day. A crew of 10 replaced the 40 men previously required for the same amount. Moving belts automatically conveyed the loose tubers to trucks traveling beside the machines. (Courtesy Barbara Peacock.)

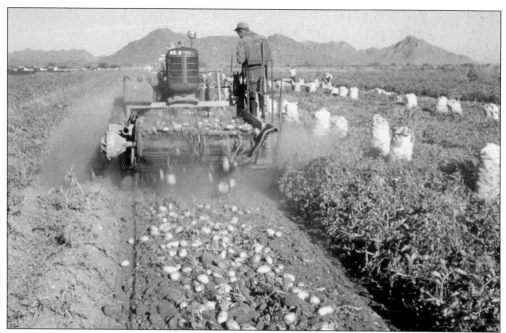

Red La Soda, a new variety tried in 1956 by Arizona's Salt River Valley growers, proved promising. A very nice-looking potato, it reportedly yielded 433 bags per acre in one test planting. Red Pontiac, the accepted variety for this region, yielded as high as 600 bags to the acre and brought prices ranging from $3 to $7 per hundred in 1955. (Courtesy Max and Carolyn Ellsworth Schnepf.)

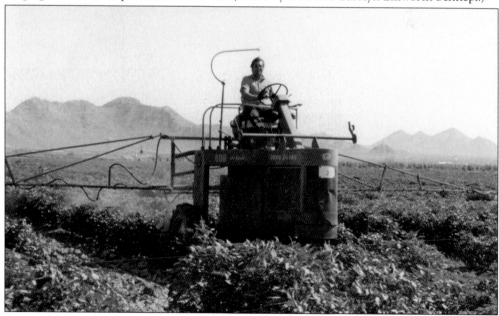

Farmers like the Brookses adopted several unique cultural practices to obtain high yields of good-quality potatoes. When planting, which they generally did in February and March, they planted the crop on flat, level ground rather than in furrowed or hilled fields. The plantings were later furrowed for irrigation, leaving the seed pieces slightly below ground level and to the side of the irrigation furrow. (Courtesy San Tan Historical Society.)

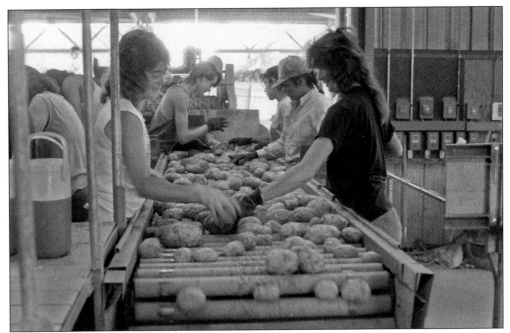

Do not forget to toss out the rocks and the snakes. The potato shed offered employment each summer, and grading potatoes was the first job for many of the youth. Schools would sometimes cooperate by letting students out a few weeks early for the harvest. There were always a few that risked getting busted—they claimed to be working but never showed up. (Courtesy Bernadette Heath.)

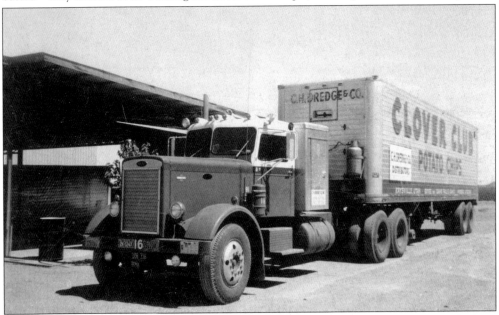

Queen Creek became known across the country for its early chipping potatoes. Because of the desert climate, these potatoes were the first of the harvest season each year and always in high demand. Thousands of semitrucks, like this one from Clover Club Potato Chip Company, would come through Queen Creek in May and June to pick up loads of freshly harvested potatoes. (Courtesy Mark Schnepf.)

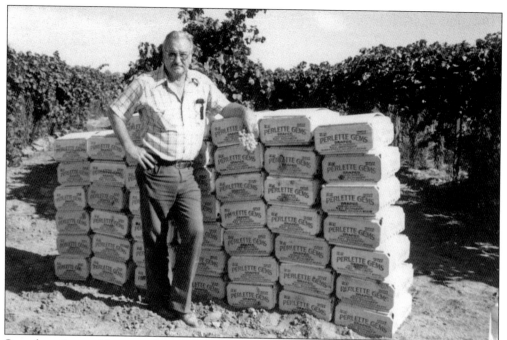

Some longtime residents say that grapes were the most beautiful crop ever grown in Queen Creek. Ray Schnepf's table grapes, made up of several varieties, were some of the earliest in the nation to be harvested and shipped. These were not wine grapes, although some residents may have made their own home versions. (Courtesy Mark Schnepf.)

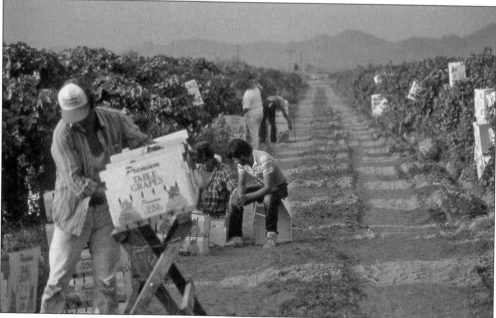

Farm workers performed much of the manual labor. Whether they were harvesting grapes on Power Ranch or on any of the other farms in the area, these laborers put in many long days under sometimes harsh climatic conditions. Competition from Southern California and Mexico put the grape vineyards out of production by the 1980s. (Courtesy Bernadette Heath.)

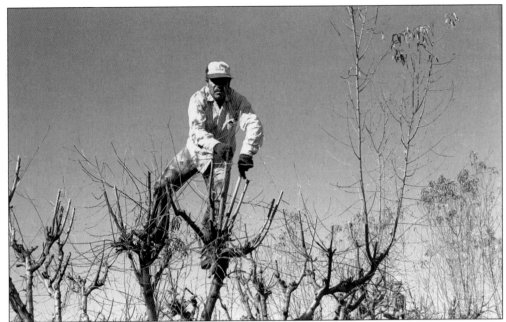

Farm workers played a significant role in both agricultural production and community development. Before machinery was available to run through the peach orchards and trim the tops of the trees, farm laborers balanced on the branches, risking injury to get the job done. Much of the communities' success can be attributed to these hardworking people with diverse cultures and values. (Courtesy Bernadette Heath.)

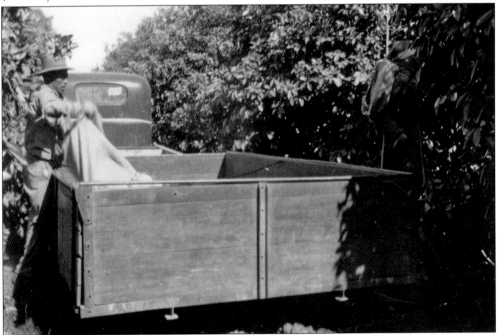

Lemon picking started in November, followed by navel oranges, and then grapefruit. Chandler Heights was one of the first citrus-producing areas to pick the grapefruit from the trees and then empty the picking sacks directly into lugs. (Courtesy Roger Nash.)

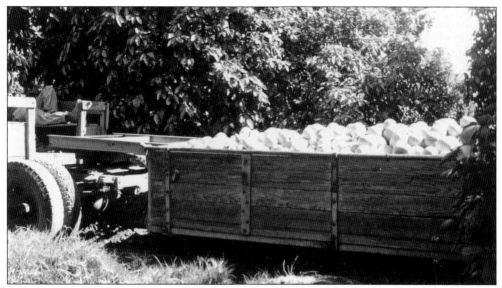

The lugs were then loaded onto trailers and towed to the packing shed. This saved precious time from the previous operation of dumping the fruit into crates to be emptied at the shed for processing. The picking and packing process was an extensive one, and speed was essential to the quality production of high-grade fruit. (Courtesy Roger Nash.)

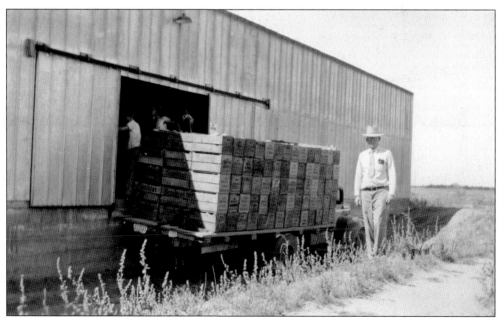

For Chandler Heights, almost all citrus was packed to order and sold before it was picked. Grading and packing operations were carried out in the packing shed owned by the Citrus Growers Association, and the citrus was sold through the Sunkist Company. The packing shed maintained an army of trailers to keep the flow of fruit running smoothly. (Courtesy Roger Nash.)

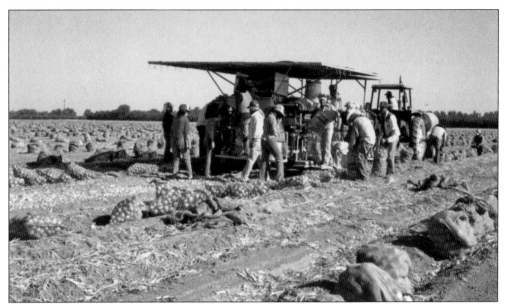

Queen Creek became well known for growing a sweet, mild jumbo onion that was popular on the East Coast. Most of the onions were shipped to repacking houses in New York. Local residents would flood the fields after harvest to take home onions left in the fields. In this 1982 photograph, the onion harvester at Schnepf Farms packs onions in 50-pound mesh bags. (Courtesy Mark Schnepf.)

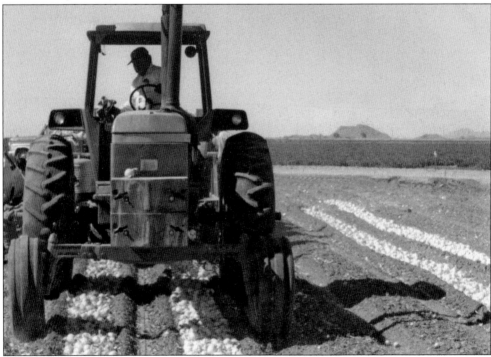

Not many people think of Queen Creek as a garlic-growing area, but the soil and climate on Schnepf Farms offered good growing conditions for this aromatic crop in the early 1980s. Here the crop of garlic is harvested for packaging and shipping. (Courtesy Mark Schnepf.)

Sossaman Farms, along with others in the area, grew cauliflower. The fields were cultivated two or three times during the production, and the crop was usually harvested between January and March. The crates were stacked high, carefully secured, and double-checked before the truck hit the road to market. (Courtesy Jamie and Sue Sossaman.)

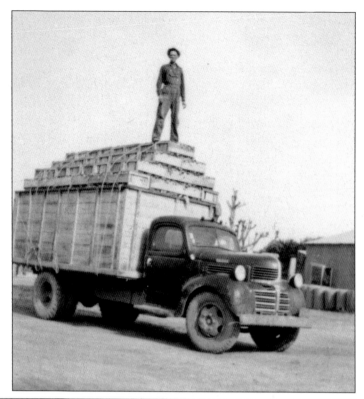

Experimental plantings of beets and other vegetables for seed production led to the construction of this cleaning mill on the Ellsworth Brothers ranch. It also served as a seed-cleaning mill and lettuce-packing shed. Popular in the 1960s and 1970s, lettuce was a very labor-intensive crop that required many man-hours for production. (Courtesy Delos and Alba Ellsworth.)

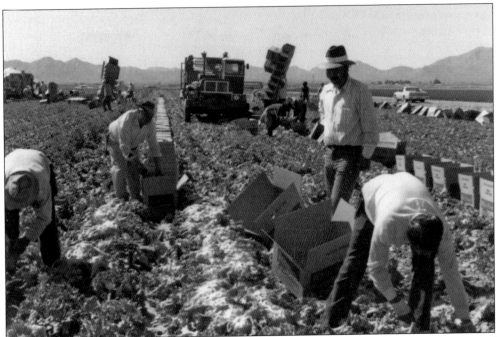

The lettuce market was volatile, and prices for the crop fluctuated wildly. A favorite saying of Ray Schnepf was "who needs to go to Vegas to gamble when you grow lettuce?" Lettuce required rapid cooling and was shipped by train and truck. An adequate labor supply became an issue before the crop was eventually phased out of production. (Courtesy Mark Schnepf.)

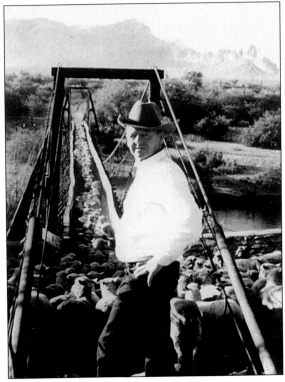

Following the harvest, flocks of sheep were sometimes put into the fields to feed on the leftover lettuce, carrots, grain, and alfalfa. Larence Ellsworth managed all livestock operations on the Ellsworth Brothers ranch, as well as the general merchandise store. (Courtesy Delos and Alba Ellsworth.)

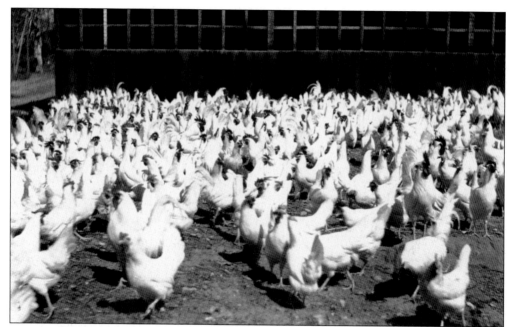

Jack Combs served as manager of poultry operations for the Combs, Combs, and Clegg partnership. Chickens were added to the operation with an initial investment for 500 cages and 500 pullets. Within three years, profits from the poultry encouraged expansion to 25,000 cages with 20,000 layers in production. (Courtesy Virginia Mitchell Minor.)

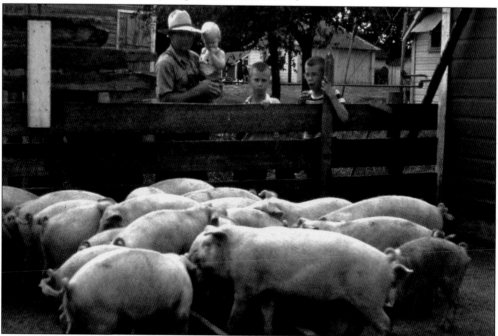

The first Landrace-bred sow and young boar were transported from Iowa in a pickup truck. As the story goes, while an attendant was pumping gas at a service station in Texas, the hog urinated, causing the man to panic, thinking he had overfilled the tank. Pigs were kept to eat waste products and to provide pork for the meat counter in the Combs store. (Courtesy Salge family estate.)

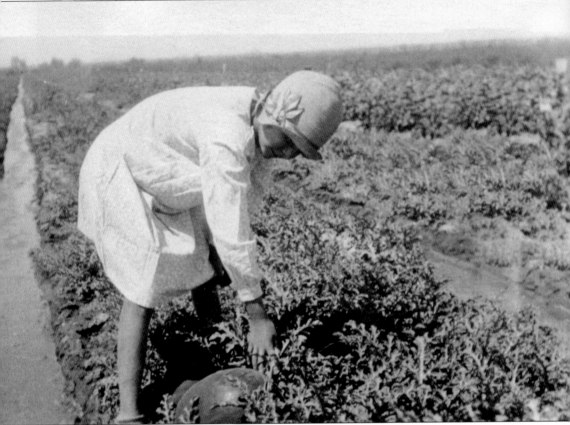

On October 6, 1993, the *Phoenix Gazette* reported that Newell Barney had given away more than 200,000 watermelons over the previous 40 years. Newell said, "People know when they see a watermelon on their doorstep in June or July, it's from me." Watermelons have been popular around San Tan Mountain ever since the first settlers—even for young Alice Harper of Chandler Heights, pictured here in 1931. During that same time, Roger Binner leased 10 acres along Sossaman Road from Dr. Chandler to grow watermelons. The property was fenced with barbed wire to keep range cattle out. The Gila River Indians from Sacaton would drive their horse-drawn wagons around the west end of San Tan Mountain and down Hunt Highway to the Chandler Heights Trading Post, and then over to the watermelon patch. They would pick the melons and then stop by the trading post on their way home to pay Roger. The transaction, repeated many times, was done on trust between all involved. (Courtesy Virginia Mitchell Minor.)

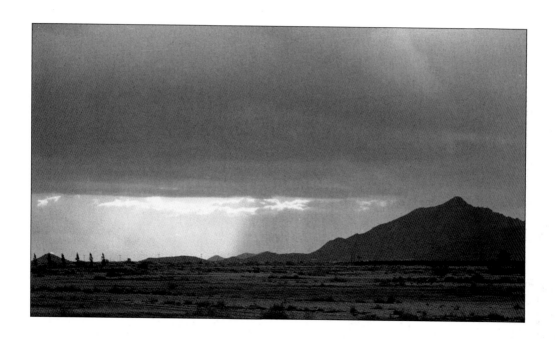

Monsoon season visits Arizona every summer, as it has for countless years. Dust, wind, and cells of rain move across the desert with an intensity that must be experienced to be appreciated and respected. One local farmer, W. R. Lacy, recalled, "On Sept. 16th, 1925, a flood came down over this entire acreage, three feet deep, damaging 210 acres of cotton. In March 1926, the water came down over new plowed land, ready to plant, washing same, had to relevel [sic], costing $250. Last part of July 1930, had a crop of hay out, and ready to bale—was a total loss due to flood of 250 ton of hay at $7.00 per ton." (Courtesy Bernadette Heath.)

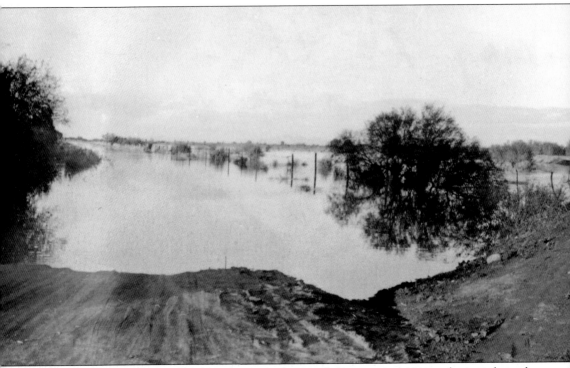

The area experienced flooding for many years, despite all the improvements made since the early 1900s and the additional engineering recommendations authorized in accordance with the Flood Control Act of June 22, 1936. One farmer, J. H. Sawyer, was very detailed about his losses from the July 1936 flood, listing "1 sack chicken feed, $1.50; 1 sack cotton seed meal, $1.46; 4 hens, $4.00; 1/2 ton baled hay, $4.00; 1 acre alfalfa killed by flood, $25.00; 10 tons hay in windrow washed away, $50.00; 30 tons hay in windrow ruined by standing water, $90.00; 10 acres cotton damaged @ $10 per acre, $100.00; and, 1 ton useable fertilizer washed out of stock pens, $1.00." One day in August 1939, Queen Creek waters rose, and for 10 hours, the road from Chandler Heights to Chandler was flooded for three-quarters of a mile near the bridge over the canal. The roads north past the Power, Sossaman, and Germann farms were also flooded. According to a report from the Queen Creek Flood Control Project, submitted for a War Department hearing on October 6, 1937, "The Leo Ellsworth's lost 600 young chickens during the high water." (Courtesy Roger Nash.)

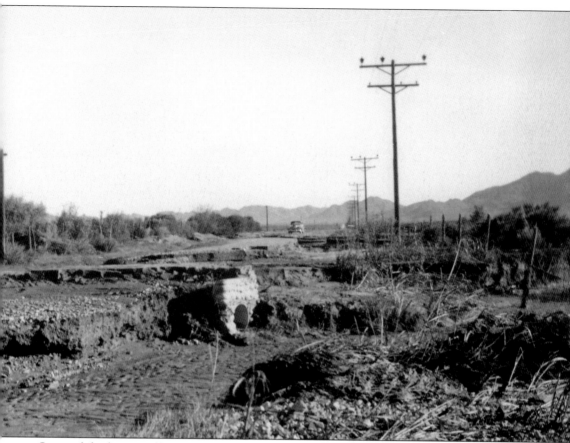

Some of the best recollections come from old *Chandler Heights Weekly* newspapers. In August 1940, a Sunday afternoon rain transformed dry washes to raging torrents. "All the tomatoes and peas planted on the Fitzgerald ranch were washed away." In August 1943, "1.52 inches of rain fell, . . . breaking a hot spell and furnishing a good irrigation to everyone." Although surveys were completed prior to World War II, the War Department's U.S. Engineer Office did not release its flood control report until February 1946. It concluded that despite previous efforts to redirect overflow, a serious flood problem still existed; that adequate flood control could be provided by a dam and basin; that water could then be released from the flood control basin at a reduced and more nearly uniform rate; and that the flow would be extended over a longer period, thus increasing natural recharge of the underground basin. The resulting recommendation was that the country adopt a project for the construction of a dam and basin at the Whitlow Ranch site on Queen Creek, Arizona. (Courtesy Roger Nash.)

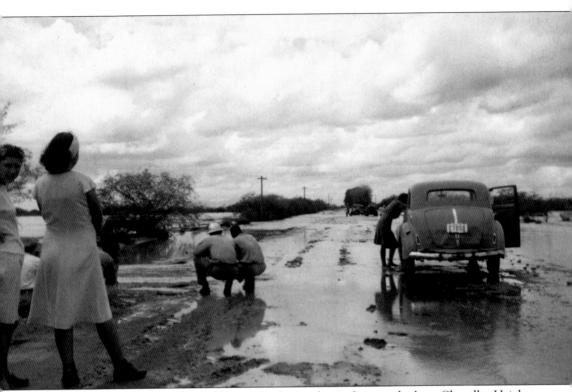

On September 19, 1946, as Betty Binner was driving home from work along Chandler Heights Road, she had to stop near the double bridges at Greenfield Road because the wash was running full of water from a recent monsoon storm. She got out of the car, took off her shoes, walked through the water, and caught a ride home, thinking she would go back for her new Ford Coupe after the water receded. Shortly thereafter, her friend Truman Mitchell drove up in her new car. He had decided to drive it through the wash and bring it home for Betty. The inside of the car was full of water and a mess. (Courtesy Roger Nash.)

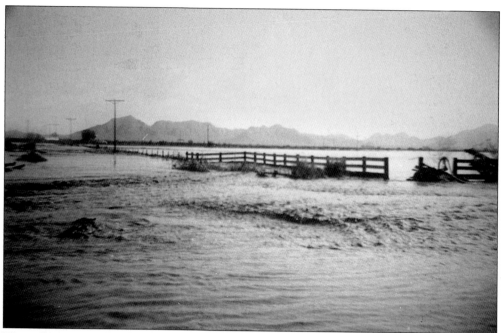

Water flowed across Crismon Road on August 19, 1954. The flood destroyed an estimated 100 acres of carrots, and a large section of railroad tracks was washed away. Nolan Ellsworth also reported that his Ford pickup was a complete loss. (Courtesy San Tan Historical Society.)

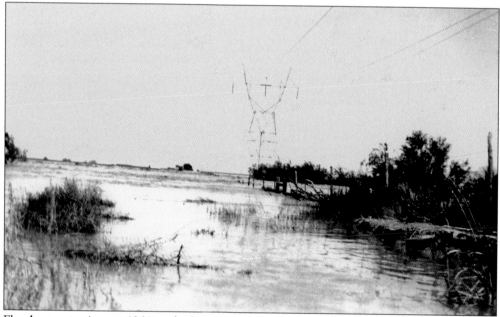

Floodwaters in August 1964 washed out a road and left sandbars and channels across flooded orchards. In September 1966, classes at the Rittenhouse Elementary School were dismissed early and closed the following day because of flooding. Water was reported to be knee-deep for a bunch of eighth graders seen trudging across the playground. (Courtesy San Tan Historical Society.)

Above, San Tan Mountain served as the backdrop for the Greer family dairy. Below, the Greers, like many others in the area, brought life to the desert with their dairy. In 1971, they could anticipate when visitors would arrive based on the distance of the dust cloud on Riggs Road. Now 35 years later, many cars pass by the Greer home on an hourly basis. Community boundaries are becoming less obvious as new housing developments replace cultivated fields. In many ways, this is exciting, as our residents are very special and we can all be proud of the diverse cultures and backgrounds that have contributed to the richness of this area. This next generation is creating a new chapter of life in the desert. (Courtesy Philip Greer family.)

# *Three*

# A SENSE OF COMMUNITY

The San Tan Mountain communities are a blend of cultures, lifestyles, and personalities.

Early homesteading failures and successes, at a time when Arizona was just establishing statehood, formed the foundation for the community of Higley. The general store and post office was its hub.

Charles Rittenhouse jump-started another community from the modest railroad siding of his Queen Creek Farms and soon gave the Ellsworth Brothers a solid footing for development. The community grew on the hard labors of many families with different faiths and values in collaboration. Roads were named in the 1940s when the tax assessor had difficulty in placing property on the tax rolls. Arizona Machinery, the company that serviced the farm equipment, was wasting rationed gasoline while trying to locate its customers. The first road signs were oil-bucket lids nailed on corner posts, identifying the names of the farmers that lived there. The community established its new identity with the Queen Creek Post Office in 1947 and achieved incorporation as a town in 1989.

The community of Chandler Heights was founded on A. J. Chandler's dream for investments in citrus groves. The vision was tempered with the stock market crash in October 1929, but citrus farmers persevered and played a significant role in the development of the area. The post office was established in 1938. A surplus barracks building was acquired from Fort Huachuca, and the community opened a school for 20 students on September 12, 1949.

J. O. Combs and his partners showed how a diverse farming operation could open up new possibilities for a community's future. By the 1950s, there were 1,870 acres of land cleared and in production, feed pens for 1,400 steers, 12,000 hens in cages, and a hog enterprise of undetermined proportions. Every partner had a home of his own—"All a mile apart," said Combs, "so that each family could settle its troubles in private." In 1954, two barracks buildings were purchased for a school and placed on five acres donated by J. O. and Mamie Combs.

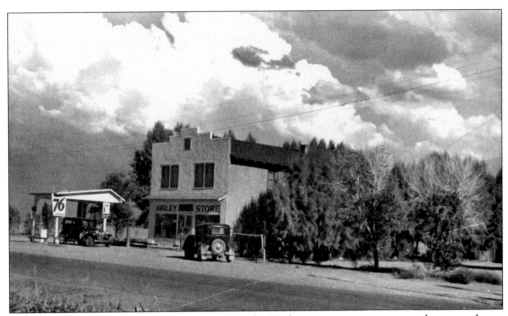

This building was constructed in 1910 to serve the Higley community as a general store and post office. At that time, a Coca-Cola could be purchased at the store for 5¢ and a cigar for 10¢. The post office served its customers from a window in the back until an addition was built to the west side in the late 1930s. (Courtesy San Tan Historical Society.)

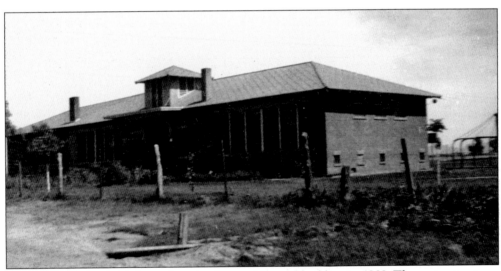

Higley School first held classes in a simple wood-framed building in 1909. The main structure, shown here, was built on the corner of Higley and Vest Roads in 1915. The original school board members included J. O. Power, S. B. Tatum, J. M. Elsberry, Walter Germann, Warren Fincher, E. E. Hawes, and Homer Owen. (Courtesy Ed and Joyce Nevitt.)

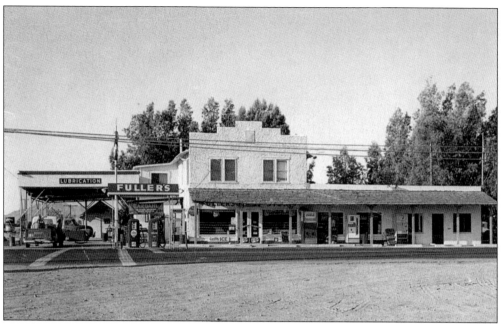

Luveda Fincher, who moved to Higley in 1936, has many fond memories of the general store. She remembers that it carried "buckets or hats or whatever you wanted to buy." This postcard claims that Fuller's General Merchandise Store and the U.S. Post Office are the center of a modern, progressive farming community in the Great Salt River Valley of Arizona. (Courtesy San Tan Historical Society.)

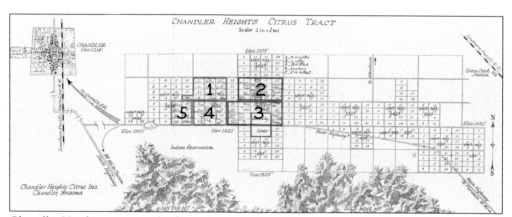

Chandler Heights was an early planned community along what was then the new Hunt Highway from Phoenix and Chandler to Tucson, via Florence. Its distance from Chandler was 13 miles. The community stretched for 7 miles east and west, gently sloping at the foot of the sheltering, picturesque San Tan Mountain range. The average north-south width was approximately 1 mile. (Courtesy Virginia Mitchell Minor.)

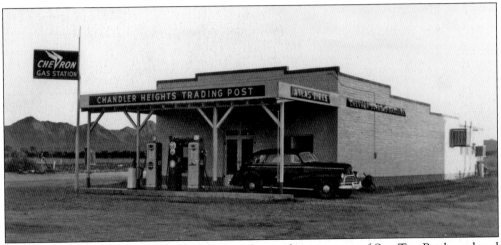

The trading post moved to a new location on the southwest corner of San Tan Boulevard and Power Road in the summer of 1946, and the post office moved with it. Tess Binner sold the store and retired in 1953. At the time of the sale, the store had an icehouse on one side and a lean-to covering the motors and compressors on the other. (Courtesy Roger Nash.)

A popular hangout spot for teenagers in Chandler Heights was Potato, or "Tator," Hill, located on the Gila River Indian reservation border and overlooking the corner of Higley Road and Hunt Highway. Pictured from left to right, Louis Power, Dorothy Jackson, Carol Ellsworth, and Paul Thatcher picnicked in the desert on this sunny day. (Courtesy Roger Nash.)

The area around San Tan Mountain was considered quite remote in early years, with only dirt roads and a few telephones. This lifestyle promoted a sense of community and kept families and friends together. Picnics, ball games, watermelon busts, and barbeques were favorite ways to spend time together. (Courtesy Jamie and Sue Sossaman.)

The boys of Queen Creek always found new ways to show off for the girls. Cliff Brandon once said, "We were country when country wasn't cool, but we didn't let that bother us any. The girls were just as pretty as or prettier than those in town." (Courtesy Jamie and Sue Sossaman.)

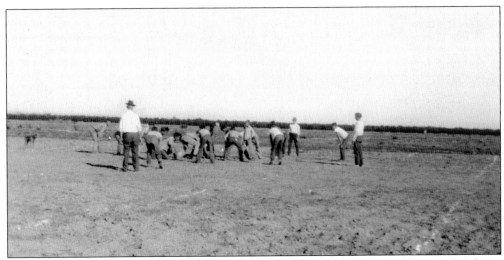

The first football game between Chandler Heights and Queen Creek occurred in 1946. A letter from the editor in the August 21, 1948, *Chandler Heights Weekly*, read, "Lately, teen-agers have been racing their cars up and down the Heights roads without regard to life and limb of children, pets or themselves." It makes us wonder if they might have just been late for another game. (Courtesy Roger Nash.)

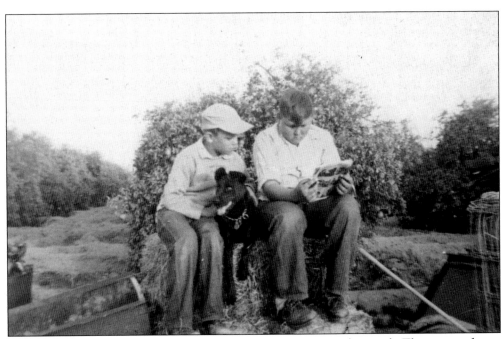

The community of Chandler Heights took pride in the education of its youth. The area was home to a diverse cross-section of youngsters, "everyone from doctors' kids to migrant kids," commented teacher Jean Scheufler. No one is sure what Larry Lindsay (left), his dog Judy, and the unidentified neighbor boy learned from this comic book. (Courtesy Barbara Lindsay Smith.)

Fires were always a concern for these small communities. The August 6, 1949, copy of the *Chandler Heights Weekly* reported, "Members of the Chandler fire department answered a call Monday evening when the big diesel pump on the Rogers ranch just north of the Heights was reported to be on fire. A spokesman for the group said it was unusual for them to go so far from town, but they knew the cost of diesel engines and wanted to help. The oil around the motor had caught fire and the blaze would soon have spread to the motor itself except for the quick work of the owners and Mr. Kizziar. The fire was under control by the time the fire truck could reach the Heights." Because of the equipment available at that time and the limited water supply, the fire could have quickly spread were it not for everyone working together in the community. (Courtesy San Tan Historical Society.)

Queen Creek was quite limited when the Barneys first settled here. Newell remembers when Queen Creek consisted of a service station, Wrights Market, the Ellsworth Brothers office, the fountain and post office, and Dory's Bar. A little two-track road ran to the Barney farm—only a few roads at that time were named, and all directions were given in distance from the general store. (Courtesy Max and Carolyn Ellsworth Schnepf.)

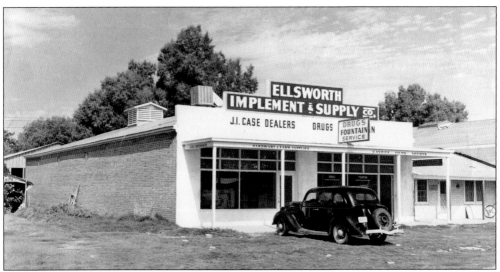

Men may get most of the credit, but no community would be possible without the women. This was also true for the Ellsworth brothers. Mary (Hansen) Ellsworth worked closely with her husband, Leo, to help manage the businesses and staff. Leona Stapley married Larence, while Margaret Cooper wed Don. (Courtesy Ruth Wales and Myrna Skousen.)

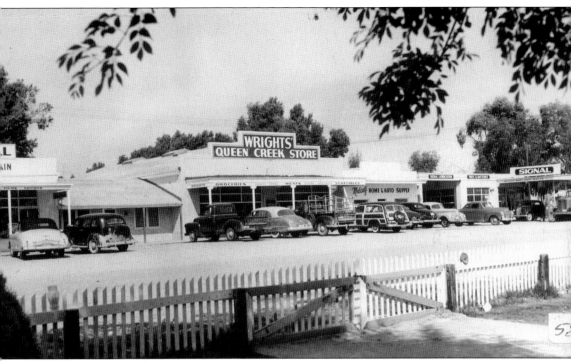

The Ellsworth Store later became Wright's Queen Creek Store. According to a 1949 article from the San Tan Historical Society archives, "The night of March 31, two unidentified persons broke into Wright's Market at Queen Creek making off with the safe and its contents valued at more than $900. The culprits, it is reported, entered the store through the front and office doors, loaded the safe possibly on a truck and hauled it a mile out on the desert where it was blown open." This same year, Barry Goldwater was elected to the Phoenix City Council, a new Dodge could be purchased for under $1,800, and Jacquelyn Mercer of nearby Litchfield was crowned Miss America—the last Miss America to be born somewhere other than in a hospital. The National Trust for Historic Preservation, founded in 1949 as well, has demonstrated how preservation can play an important role in strengthening a sense of community and improving the quality of life. (Courtesy Frances Brandon Pickett.)

Lee Sossaman's children enjoyed cooling off in the water while visiting with their uncle Jasper. Queen Creek really started to develop a sense of community in the late 1940s and 1950s. Far away from neighboring towns and connected for years by only dirt roads, the residents looked to themselves for friendship, fellowship, and fun. (Courtesy Jamie and Sue Sossaman.)

The community's first real swimming pool, at Schnepf Farms, was a welcome change from the sandy, bottom-fed pond located by a fresh well on the Tenny dairy. The pool, shown about 1950, was a gathering place not only for family members but for many others in the community. Here Queen Creek's first Fourth of July fireworks were displayed. (Courtesy Mark Schnepf.)

Pilot training began in February 1942 at Williams Air Force Base, named in honor of Lt. Charles L. Williams, a pilot who lost his life in an aircraft accident in 1927. During the war years, the skies were full of trainer planes making touch-and-go practice flights. On holidays and Sundays, visiting airmen were invited to homes for meals and horse rides in the desert. (Courtesy Roger Nash.)

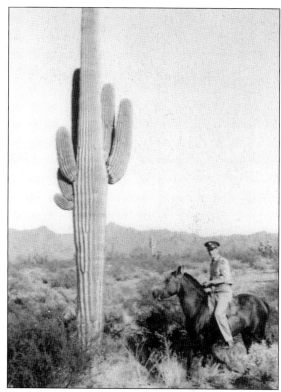

The base turned out fighter and bomber pilots, bombardiers, and navigators during World War II. It was used for gunnery training of air force fighter crews from 1946 through 1959. In October 1960, the base returned to its original mission of training new pilots, many from foreign lands. This English air cadet liked showing his skills with one of the Binners' horses, especially when Betty was watching. (Courtesy Roger Nash.)

Capt. Robert Bonebrake successfully bailed out after his P-80A aircraft snapped suddenly out of control and crashed 10 miles south of Williams Field on November 3, 1946. During World War II, Captain Bonebrake reportedly shot down three enemy aircraft in the air and two more on the ground from his 78FG. (Courtesy Roger Nash.)

The new Queen Creek Ward of the Church of Jesus Christ of Latter-day Saints first began in 1949 without a meetinghouse. The school district allowed the ward to use a barracks building located on the school grounds until a new chapel could be constructed. (Courtesy Max and Carolyn Ellsworth Schnepf.)

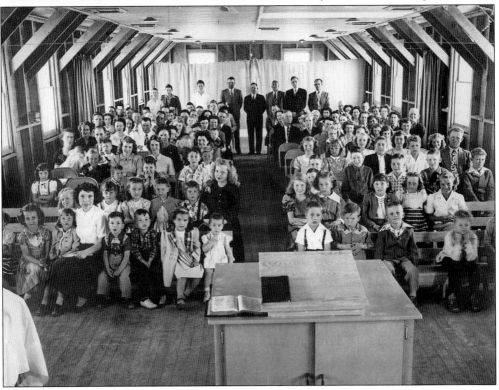

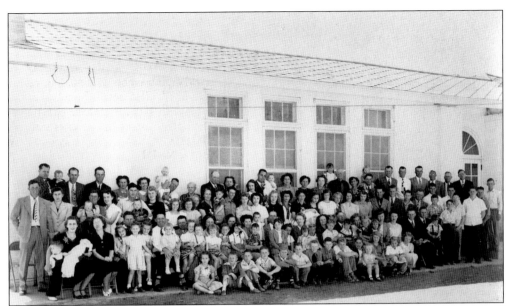

The first meeting of the Church of Jesus Christ of Latter-day Saints was held on March 13. And soon after the organization of the new Queen Creek Ward, it became quite evident that the number 13 was destined to become lucky for the ward and its membership. The bishop was also born on a Friday the 13th. (Courtesy Newell and Katherine Barney.)

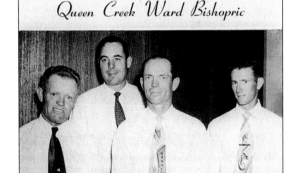

Queen Creek Ward Bishopric

Pictured left to right: Earl M. Brown, first counselor; Stan Turley, second counselor; John A. Freestone, bishop; Max Schnepf, ward clerk.

The completion and dedication of our new chapel marks a milestone in the progress and growth of the Queen Creek Ward. At this time we wish to express the joy and gratitude in our hearts for what we have been able to accomplish in the name of the Lord.

There has been real satisfaction in experiencing the spirit of cooperation and willingness on the part of the members and friends of the ward to devote their talents, time, labor, and money toward the completion of this building. However, we are sure that none feels that he has made a sacrifice, but rather that he has had a privilege in doing something to establish the Church of Jesus Christ of Latter Day Saints.

The Church and surrounding grounds have been designed to serve many religious purposes. A beautiful chapel has been provided for worship. Class rooms have been carefully arranged so as to permit the best facility for teaching and learning the gospel. An adequate social hall has been provided to care for the recreational activities and the cultural development and expression of the membership. Adjacent to the social hall is a well equipped modern kitchen providing facilities for the preparation of refreshments and meals.

Again we take this opportunity to thank each one who has assisted in this building program. We are sure that you join us whole-heartedly in dedicating the building and the premises to the service of the Lord.

Queen Creek Ward Bishopric
JOHN A. FREESTONE
EARL M. BROWN
STAN TURLEY
MAX SCHNEPF

Ground-breaking ceremonies for the new chapel commenced on April 13, 1951, just 13 months to the day from the initial meeting of the ward. The first meeting in the new building was held on Mother's Day—you guessed it—Sunday, May 13, 1951. Pictured here from left to right are Earl M. Brown, Stan Turley, John A. Freestone, and Max Schnepf. (Courtesy Max and Carolyn Ellsworth Schnepf.)

# Church of Jesus Christ of Latter-day Saints
# QUEEN CREEK WARD

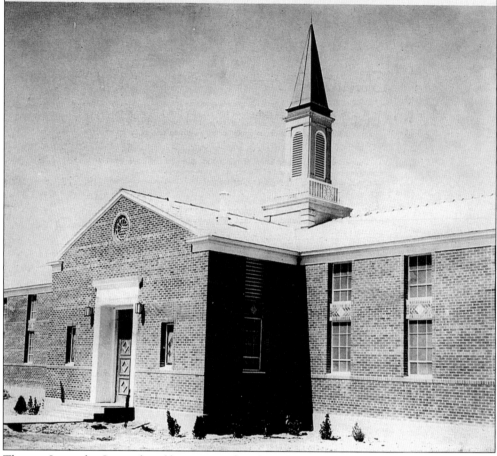

The new Latter-day Saints chapel became a reality through contributions of labor, land, and money. One fund-raising event attracted statewide attention: a big cotton-picking day on the Earl Brown farm. Services of 14 cotton pickers were donated to pick 80 acres of cotton in a single day. That day, the machines earned $2,600 for the building fund. When dedicated in 1952, the chapel and the adjoining athletic field, with its lighting system and landscaping, represented an investment of approximately $100,000. The Queen Creek Ward held its last meeting in this chapel in March 1989. On November 7, 1990, Queen Creek community leaders authorized the purchase of the building for the Town of Queen Creek—the deed was signed in February 1991. Located just south of Ocotillo Road on the west side of Ellsworth Road, the unique town hall bears stained-glass windows in its council chamber. (Courtesy Max and Carolyn Ellsworth Schnepf.)

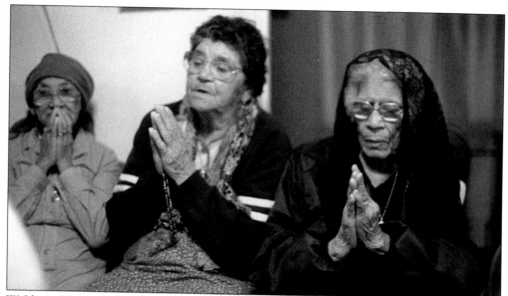

Waldo and Rosenda Aldecoa's motto for their 13 children (three of whom are shown here) was "you are given two hands, one is for taking and the other must be for giving." The families and farm laborers who moved to the Queen Creek area in the late 1920s and early 1930s began, with the help and guidance of Fr. Charles O'Hern, to organize the first Catholic congregation in the late 1940s. (Courtesy Bernadette Heath.)

For many in the community, their faith was incorporated into every aspect of their daily lives. The school district had acquired several wooden barracks for use as classrooms, a cafeteria, and an auditorium. The auditorium doubled as a facility for mass and for the visiting priest to hear confessions. Nuns would also teach catechism classes, usually during the summer. Although congregation members appreciated the use of the school building, they looked forward to a time when they could worship in their own church. (Courtesy Bernadette Heath.)

The two narrow stained-glass windows may have first caught your attention as you passed by the weathered building. Though obscured by afternoon shadows, their beauty enticed you to take a second look. The Catholic congregation started raising money for a building fund in 1960 by selling homemade items such as baked goods. Father Patterson of Chandler helped with the purchase of property, and Father O'Hern of Gilbert helped acquire a barracks building from Williams Air Force Base. It was moved to the site on the north side of Ocotillo Road, three-eighths of a mile west of Ellsworth Road. By 1975, the barracks building was deemed unsafe, and the insurance company refused to renew the policy. New fund-raising efforts began, many under the leadership of Lupe Coronado. In 1988, land was purchased across the street for Our Lady of Guadalupe Church. (Courtesy Bernadette Heath.)

The Community Presbyterian Church was a welcome meeting place for the residents of Chandler Heights and the surrounding area. This photograph, taken in October 1953 by Rev. Kenneth Snead, shows his wife holding a child and gathering with a few of the other church members. Barbara Lindsay recalls fond memories of playing the piano with her sister Madonna and singing with her mother, Alice. A small youth group met on Sunday evenings, and parents were always present to direct the activities. Other memories include the annual Easter egg hunt, when adults would hide eggs on the desert near the church for the children to discover. Barbara humorously remembers one year when an encounter with rattlesnakes abruptly halted the event. (Courtesy Barbara Lindsay Smith.)

Mrs. ? Close sits on the back bench and enjoys her picnic meal while Ruby Mitchell (left) and Winnie Wellington get their photograph taken. "Twenty-five Present at Annual Picnic Held in Desert Rain" was the headline in the *Chandler Heights Weekly* of January 3, 1942. According to the article, "The sun hid and rain fell the afternoon of January 1 while twenty-five Heights residents and friends held their eighth annual New Years Picnic on the desert in a sandy wash under beautiful blue-green iron wood trees. The group enjoyed their pot-luck dinner before the shower so everything on the table was just covered by a canvas tarp and people sought shelter in cars. Though the ground was damp the New Year spirit of the crowd did not seem to be effected. The group pitched horse shoes, listened to a New Year football game and played baseball between showers. Mrs. Binner, whose idea it was to have this annual picnic is now gathering together all the pictures of it from past years and enclosing them in a scrap book." (Courtesy Virginia Mitchell Minor.)

George (center) and Sylvia Close were regularly featured in the Social Notes section of the *Chandler Heights Weekly*. On October 2, 1948, everyone learned, "Wednesday guests of Mr. and Mrs. G. H. Close and son were Mrs. W. E. Freeman, Phoenix, Mrs. A. M. Hector and son and Mrs. Dick Strickland, Chandler." Here the couple sits in the shade with Roger Binner. (Courtesy Roger Nash.)

Alice Lindsay (right) of Chandler Heights enjoyed singing along with her friend Gerry Donovan. Bill Donovan made a recording of the two singing "Suddenly There's a Valley" on an old-style 78-speed record, to be played on the home Victrola. (Courtesy Barbara Lindsay Smith.)

The Ground Observer Corps (GOC) of the 1950s was a group of citizens who assisted Williams Air Force Base (WAFB) by keeping an eye out for low-flying aircraft. The observers were required to go outside during daylight hours anytime a plane was heard flying nearby and attempt to identify it. Each observation would be documented. On the off chance it could not be easily identified, the observer relayed what he saw by calling a special telephone number that was a direct line to the tower at WAFB. Each observer, given a special spiral reference book with types of aircraft, also wore a white helmet with a Civil Defense sticker on the front and an armband signifying him or her as an "Official Observer." The group disbanded in the late 1950s, when radar technology improved at the base. (Courtesy Roger Nash.)

By 1956, the Witt children were growing up fast. Ardell and Martha Witt were married after his discharge from the war but were unable to take a honeymoon. Ardell did promise Martha, however, that someday he would make it up to her. Finally in 1981, Ardell made good on his promise, taking time off for a romantic getaway to the Grand Canyon. (Courtesy San Tan Historical Society.)

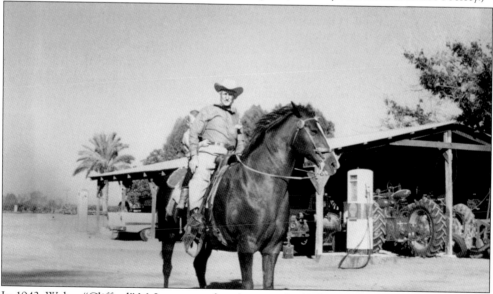

In 1943, Walter "Clifford" McLean moved to Arizona. At 68, he wanted to see how his nephew Charlie Brandon had transformed this desert into productive farmland. Uncle Cliff bought a horse when he was in his 80s and would ride his horse Tony to the store every day, as shown in this 1962 photograph. At the age of 90, doctors restricted him from riding. (Courtesy San Tan Historical Society.)

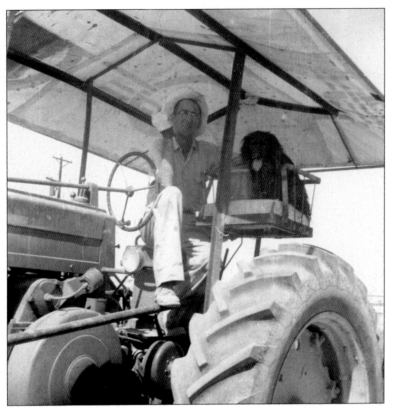

It is a dog's life. Gene and Julia Hall moved to Queen Creek with their daughters Barbara and Connie in 1951. Their dog Spooky, never far from Gene, would run himself to exhaustion trying to stay within petting distance. To solve this problem, Gene installed a special seat for Spooky on the tractor. (Courtesy Barbara Peacock.)

Gene Hall served as president of the Queen Creek Farm Bureau for one year and took the lead on a number of road improvement projects. The Farm Bureau was successful in paving the main roads for safer travel by the school buses. Gene even loaned some of his own equipment to ensure the success of these projects. (Courtesy San Tan Historical Society.)

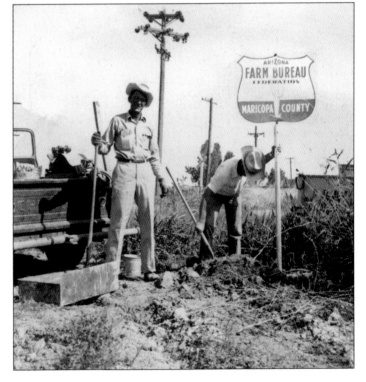

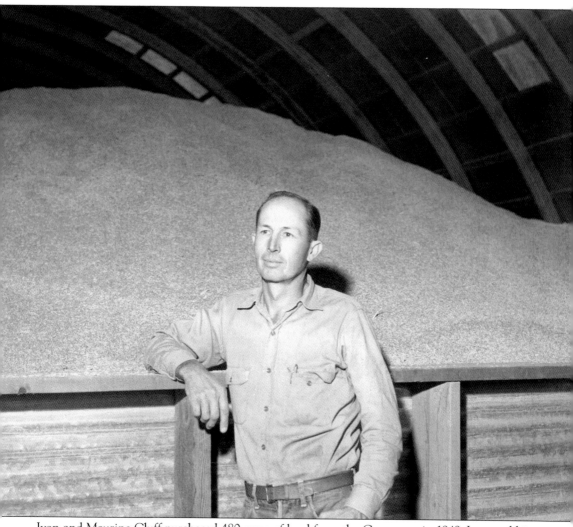

Ivan and Maurine Cluff purchased 480 acres of land from the Germanns in 1949. Ivan and his good friend Stan Turley soon formed a partnership to farm the land. As partners, they borrowed $8,000 from Stan's dad to purchase an old diesel engine and convert it to natural gas as power for the irrigation pump. Electricity was being rationed, so they had to use something other than an electric motor. Stan's wife, Cleo, once commented that they really did start from scratch, "having about $200 between the Cluffs and Turleys." These families put a lot of love into their homes over the years, like many do, making improvements and adding rooms to accommodate their growing members. Trees hit by lightning, prehistoric artifacts discovered while clearing the land, pump engines so loud that they shook the house, and children boarding the school bus are just some of the sights and sounds attributed to this developing community. Ivan used this Quonset hut for storing grain or seed. (Courtesy Ivan and Maurine Cluff family.)

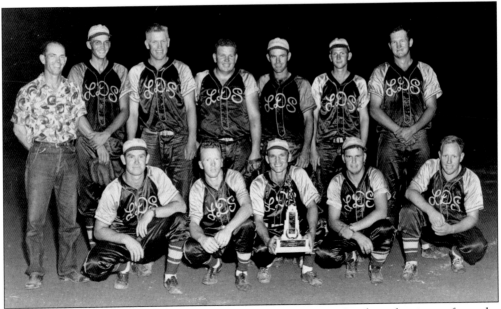

The Latter-day Saints—one of eight softball teams in Queen Creek at the time—formed a championship team in the early 1950s. Community churches and cotton gins would come together to sponsor the sport. A few years later, the team went on to Salt Lake and won the fast-pitch All Church Softball Tournament. (Courtesy Newell and Katherine Barney.)

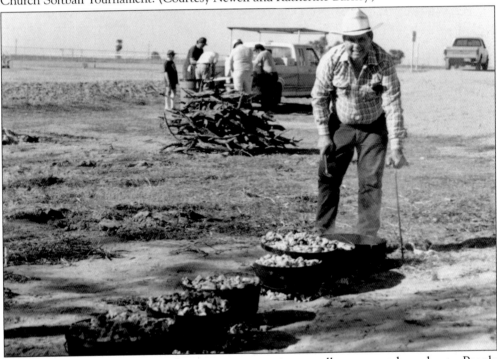

Newell Barney was well known for community service as well as top-notch cookouts. People would come for miles just for his Dutch-oven biscuits. When the corn was ripe, he traditionally staged a big corn roast on the desert. Everyone sat around big bonfires at night to enjoy the fresh roasted corn on the cob. (Courtesy Newell and Katherine Barney.)

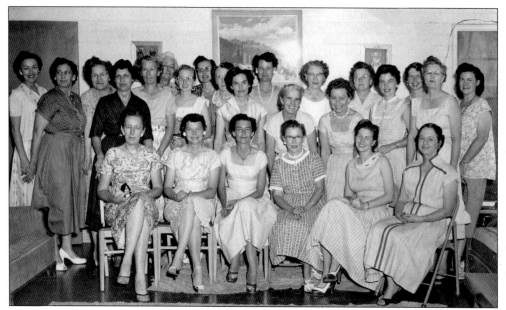

The Desert Diggers Garden Club yearbook for 1957–1958 reminds us that the club flower was the rose. Meetings were held September through May in the homes of Higley and Queen Creek members. The group's mission was to stimulate interest in gardening and roadside planting and to encourage the study and conservation of native plants and wildlife in Arizona. (Courtesy San Tan Historical Society.)

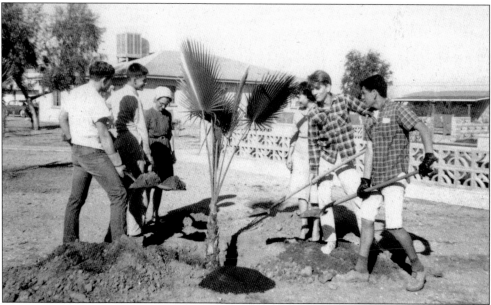

Since its beginning, the Desert Diggers Garden Club promoted community while working closely with the Arizona Boys Ranch. Each Christmas, members presented every boy on the ranch with a box of homemade candy and cookies. They also sponsored beautification projects with the boys such as planting trees on the ranch grounds and the surrounding area. This collaboration helped the boys learn about the benefits of active participation in community services. (Courtesy Barbara Peacock.)

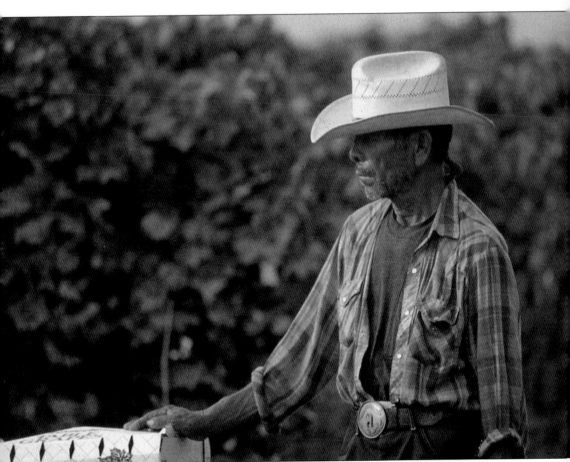

According to a recent United Farm Workers white paper, wages of the more than two million farm workers in the country have failed to keep pace with inflation over the past 20 years, making it often impossible to afford the basic necessities of housing, food, health care, and education for their children. Farm workers perform backbreaking manual labor and do not normally receive such benefits as health insurance, pension plans, and paid vacation—or even overtime pay for working more than eight hours per day. Most estimates place the Mexican and Central American farm worker population at over 90 percent of all farm workers in the country. While most speak only Spanish, there is an increasing number who speak neither Spanish nor English but rather the native languages of the region from which they came. The fact that the vast majority of farm laborers are non-white adds a dimension of racial and ethnic discrimination—not only in terms of employment practices, but also in the relationships within the workers' established communities. (Courtesy Bernadette Heath.)

Aviation provided recreation but also assistance for farming operations. The "Flying Farmers" could check their crops by air, fly from farm to farm in a short time, and pick up needed parts and supplies from downtown Phoenix and other areas. This photograph, taken in 1954, shows, from left to right, Jackie Schnepf, Thora Schnepf, Maude Schnepf, Lonnie Schnepf, Max Schnepf, and family friend and fellow farmer Gerald Mecham. (Courtesy Mark Schnepf.)

Becoming one of the largest "truck gardens" in Arizona, Schnepf Farms began selling produce directly to the public from its produce stand in 1979. The popular produce stand, now a country store, bakery, and restaurant, is pictured here in 1990. People are known to drive long distances to buy fresh goods directly from the farm. (Courtesy Mark Schnepf.)

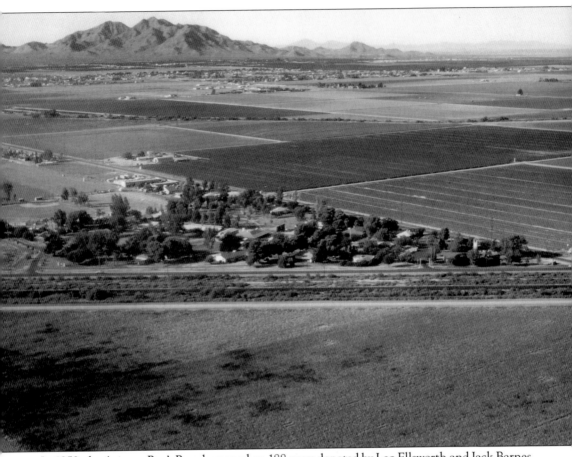

In 1950, the Arizona Boy's Ranch opened on 188 acres donated by Leo Ellsworth and Jack Barnes. The ranch grew out of the conviction that underprivileged boys should have an opportunity for home, school, church, and community regardless of their status. Many thought that the so-called juvenile delinquent boys should not be incarcerated at the Fort Grant juvenile facility but given opportunities for a brighter future. The original plans called for a self-sufficient operation that included an animal husbandry program of beef, pork, chickens, and sheep. It was hoped that the farmland, coupled with this program, could take care of the material needs of the boys and staff. The first boy arrived on September 28, 1951, when the original cottage was completed. In September 1954, the second cottage was finished and 20 boys were in residence. The two cottages were soon followed by a barbershop, a woodshop, a shoe repair shop, a butcher shop, a maintenance shop, a laundry, a clothing store, a food pantry, and a bike shop. (Courtesy San Tan Historical Society.)

*Four*

# RITTENHOUSE ELEMENTARY SCHOOL

In 1924, the construction of a new schoolhouse began a half-mile north of Rittenhouse. Named after Charles Rittenhouse, the new school was a three-room building constructed of Arizona red brick. In 1936–1937, restrooms and two more classrooms were added to the rear of the existing building. Steam heat from a boiler under the floor was disbursed through radiators in the rooms. The rooms were later equipped with oil heaters, which were again upgraded to gas heaters hung from the ceilings. A number of changes were made over time to accommodate the needs of the growing community. The stage was removed to allow for a home economics classroom, and the roll-down room dividers were framed behind solid walls.

The need to provide more classrooms for children in the midst of a developing community is nothing new. The solution for many school districts in the late 1940s and early 1950s was to acquire old barracks buildings through the War Assets Administration. The Queen Creek School District received this acknowledgment in a letter dated July 23, 1947: "Your application for buildings located at the Marana Army Air Field, Marana, Arizona, has been accepted." In September 1949, several more buildings were acquired from the former Florence POW camp for use as classrooms, offices, an auditorium, and a cafeteria.

The last words to be neatly printed on a Rittenhouse School classroom chalkboard read, "Today is Thursday, Sept. 2, 1982. The weatherman said that it will be 116 degrees today. Jessica is queen today."

After years of the Rittenhouse School standing idle and falling into disrepair on the southeast corner of Queen Creek and Ellsworth Roads, the San Tan Historical Society signed an agreement with the Queen Creek School District to take charge of its restoration. The building was placed on the Arizona Historical Registry in 1990, accepted by the National Register of Historical Places in 1998, and currently serves the community as a museum.

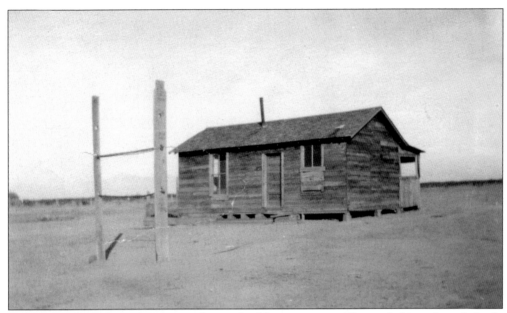

Early settlers worked together to meet the needs of the community. This muleskinner's cook shack, which had served Gid Duncan while he was clearing the land with his mules and machinery, became the community's first school in 1920. All it took were a few repairs, and the addition of a playground "monkey-bar" made from some unused lumber and pipe, to put it back in use. (Courtesy San Tan Historical Society.)

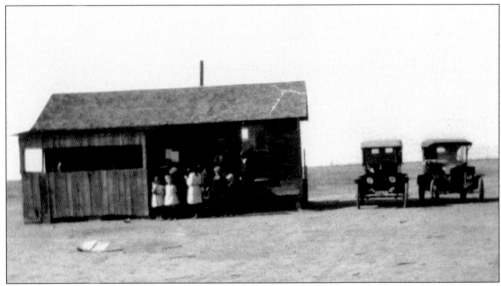

Since every family member, from the youngest to the oldest, was needed to keep the farm operating, many children put their education on hold. Mrs. Mahoney served as the first teacher in the Rittenhouse area. Her classes were typically made up of teenagers with little to no previous education. Class schedules were dependent on students' availability between planting, harvesting, and chores. (Courtesy San Tan Historical Society.)

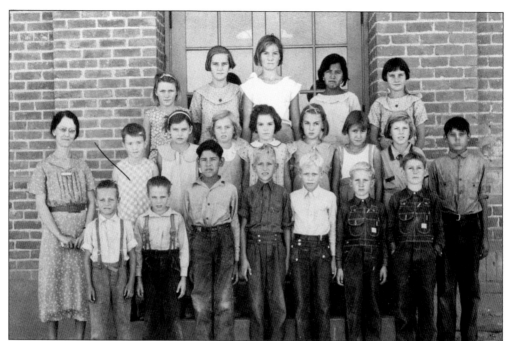

Edna Owens's class of 1936–1937 included a student by the name of Frances Brandon (second row, third from left). Frances, who was not always the best-behaved student, remembers Mrs. Owens as a very strict disciplinarian. Frances became a teacher at the Rittenhouse Elementary School years later. (Courtesy San Tan Historical Society.)

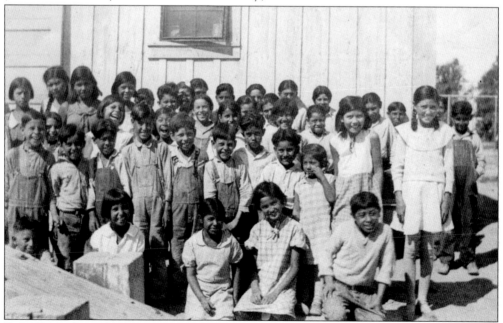

Spanish-speaking children attended school following the winter cotton harvest. Sometimes as many as 60 students were taught in a single room. After learning English from Faith Sossaman, they would integrate with the other classes. Unfortunately, many dropped out to work in the vegetable fields. (Courtesy San Tan Historical Society.)

September 19, 1949

SEMI-ANNUAL REPORT TO:

Thomas L. Peyton
Director, Non-Industrial Division
Office of Real Property Disposal
War Assets Administration
Washington 25, D. C.

Dear Sir:

I wish to report the following uses of buildings transferred
to our school district:

Ref: PNI-P
Marana AAF
W-Ariz-36
T6, T39

    Building # T-6, size 20x100  used as classrooms
          # T-39, "   20x50   used as cafeteria

Ref: RSF 10:PNI (or RSF-C-PD)
Florence POW Camp
W-Ariz-30
T6, T10, T43

    Building # T-6 used as auditorium and classroom
    Building # T-10 building paid for and title sent but since
           our school was financially unable to pay for
           high moving costs the building was left standing
           on Florence POW Camp site and assumed to be
           now in other hands.
    Building # T-43 now in @@ use as classroom and office.

I trust this meets our report requirement. If other
information is needed I will gladly comply.

                Very truly yours,

                Maurice C. Williams, Principal

In a letter from Principal Maurice Williams dated September 19, 1949, two buildings from the base at Marana were set up for a classroom and a cafeteria. Two other buildings from the former Florence POW camp were designated for an auditorium, classrooms, and an office. Receipts show that the purchase price for a single building was $50.25. (Courtesy San Tan Historical Society.)

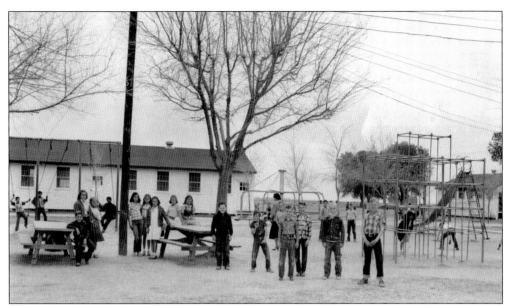

One of the barracks is shown in this photograph of the playground, taken in 1953. This same year, the second season of *The Honeymooners*, with Jackie Gleason, Audrey Meadows, Art Carney, and Joyce Randolph, could be enjoyed while eating one of Carl Swanson's first TV dinners. And in Nepal, Sir Edmund Hillary was making the first recorded climb of Mount Everest. (Courtesy San Tan Historical Society.)

Homer B. Elledge served as principal from 1952 to 1977. Every Friday morning, all of the students lined up outside by classes, facing the flagpole. Several students then raised the flag and one was selected to lead everyone in the Pledge of Allegiance. Elledge taught the students reverence and patriotism, personally dealing with anyone not displaying the proper respect. (Courtesy San Tan Historical Society.)

In 1955, the Rittenhouse Elementary School (Old Main) was a centerpiece for the community of Queen Creek. The oak floors were tongue and groove, and the blackboards were real slate. Two roll-down room dividers separated the three rooms, and the small stage was equipped with an abbreviated fly loft. (Courtesy San Tan Historical Society.)

The barracks are gone, but the old merry-go-round and some of the other playground equipment from years past are still available for viewing. It is important for the community to closely monitor its historic treasures, and thanks to the efforts of the San Tan Historical Society, this gem will continue to welcome visitors from around San Tan Mountain. (Courtesy San Tan Historical Society.)

# Five

# Old Man of the Mountain

Mansel Levi Carter (1902–1987) was his name. His early years were similar to many young men. He attended Olney Friends, a Quaker boarding school in Barnesville, Ohio, and worked as a mechanic at his uncle's auto repair shop. He fell in love. And because he respected his parents, he did not marry his sweetheart when his mother expressed her disapproval.

Carter left home in the mid-1920s and moved to Indiana, where he learned to fly a Ford tri-motor plane. During this time, he also learned to take and develop photographs. The charter service where he worked as a pilot depended heavily on business clientele, so when the stock market crashed in 1929, it went out of business.

He then traveled southwest to New Mexico and worked on the Zuni Indian reservation as a logger. After a few years, he again pulled up stakes and headed northwest. A mysterious thing happened on this leg of his journey, something Carter could never explain. As he was traveling through the Navajo reservation, the native people welcomed this *belagaana* by name and said that they knew he would be passing through.

After a stint as a sheepherder in Montana, he went on to the Salmon River area of Idaho to work odd jobs. He left Idaho and headed for Arizona in December 1941.

In Gilbert, Arizona, Carter managed a photography business. He soon became friends with the man who delivered ice, a Cherokee Indian from Oklahoma named Marion Kennedy.

Carter joined Kennedy on weekend mining adventures, searching the San Tan Mountain area for precious metals. After the war, Carter decided that this was the lifestyle he wanted. He and Kennedy set up camps on Goldmine Mountain, an area just east of San Tan Mountain.

Carter was not a man of great accomplishments, at least by today's standards. He did not amass a great fortune. But if wealth and success can be measured through how he enriched the lives of others or through how he is remembered, Carter died on June 5, 1987, a very wealthy man.

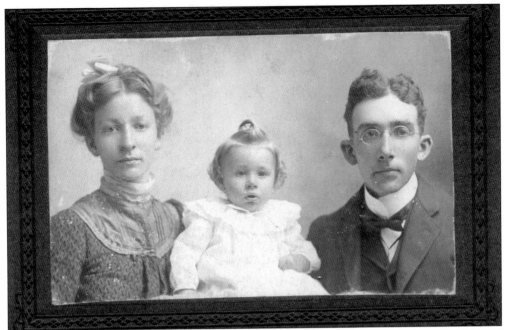

Mansel Levi Carter (center) was born near Quaker City, Ohio, on May 12, 1902, the oldest of Ellis T. and Mary Alice Hall Carter's six children. Wilma, Russell, Martha, Harold, and Alice were his siblings. His mother wore her wedding dress for this family portrait, taken in 1904. (Courtesy Alice Bates.)

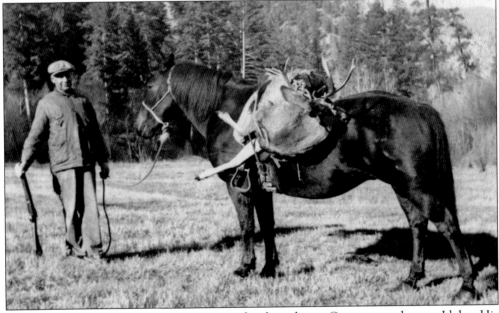

After working for a short time in Montana herding sheep, Carter moved on to Idaho. His experience as a mechanic always served him well, and he again applied these skills at odd jobs in the Salmon River area with local farmers. Carter always enjoyed spending time outdoors and would take frequent hunting trips. He left Idaho and headed for Arizona in December 1941. (Courtesy San Tan Historical Society.)

Mansel Carter was drafted and served in the Army Medical Corps during World War II but was released early because of his age and related health concerns. Upon his return to Arizona, he worked as a repairman on farm equipment and resumed his weekend adventures with Marion Kennedy. (Courtesy Alice Bates.)

In 1948, the men decided to turn their weekend passion for mining into a permanent lifestyle. They set up camps on Goldmine Mountain and spent their first year living under a palo verde tree. Mining was accomplished with hand drill bits and dynamite. To drill a hole, Kennedy, whose eyesight was failing, would hold the bit while Carter hit it with a sledgehammer. (Courtesy Barbara Peacock.)

They worked their claims as a team until Kennedy died of throat cancer in 1960 at the age of 86. Carter buried him near their camps using dynamite to blast away the rock. In fact, he used so much dynamite that when it was time for Carter to be buried next to his longtime friend, the grave was dug with much less effort. (Courtesy San Tan Historical Society.)

After Kennedy's death, Carter stayed at his mountain camp and communed with the small animals that trusted him for bits of food, affection, and medical care. Local residents also brought him injured birds. Before long, he was surrounded with the hawks, quail, ducks, chickens, and pigeons that he had helped recover from injury. (Courtesy San Tan Historical Society.)

Although he refused Social Security benefits as a matter of principle, Mansel Carter received a small pension from his time served in the Army Medical Corps. This, along with the income from his carvings, provided him with everything he needed. His only modern convenience for many years was a little portable radio for listening to the Dodgers baseball games. (Courtesy Kim Sossaman.)

Carter had filed 55 claims on Goldmine Mountain. He once told a friend, "There are places, rich places with good stuff, good size loads." But he never revealed these prized locations, even to his closest friends and family—because, many believe, he wanted to protect the habitats of his beloved animal companions. (Courtesy Barbara Peacock.)

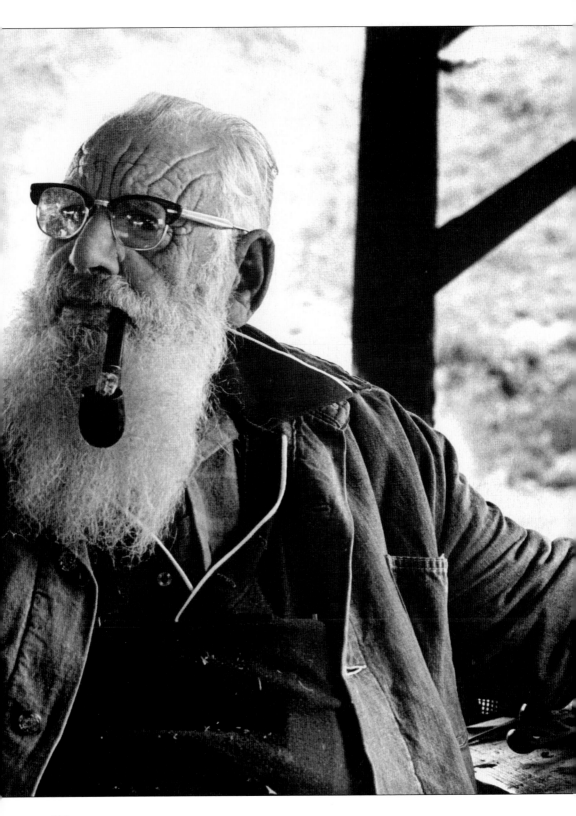

Mansel Carter had a way with small birds and four-legged creatures—a respect and understanding that can only come from the heart. Most common were the cactus wrens, brown thrashers, desert sparrows, woodpeckers, roadrunners, and occasionally a hummingbird. He also made friends with lizards and squirrels, but Gila monsters and rattlesnakes were another story. He saw rattlesnakes once in a while and amused a friend by saying, "I don't worry about them; my birds don't let them come around. Last time a snake came up here six or eight birds were around that feller raising heck. I went out and killed him and moved back a ways. The birds all paraded past him to make sure he was dead. Then they flew away." (Courtesy Ron Hunkler.)

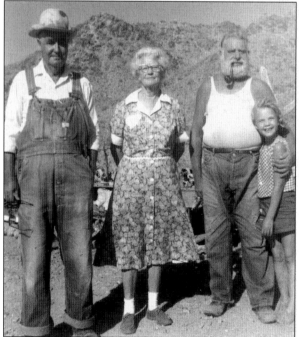

"The Hermit," as Carter sometimes called himself, crafted his Cactus Curios from pieces of saguaro, cholla, and ocotillo with a pocketknife and an old handsaw. He sewed the small pieces of clothing by hand from scraps of donated material. For 25 years, the *Prospector and Mule* was his most popular carving. It sold for $10. (Courtesy San Tan Historical Society.)

Over the years, Carter became a genuine celebrity, welcoming visitors from all over the world. He started using a red spiral notebook as a guest register in the early 1960s and had amassed a collection of more than 20 notebooks by the time of his death. They list names from all 50 states and many foreign locations. (Courtesy Kim Sossaman.)

According to the people who knew him well, Mansel Carter's fresh-baked biscuits were the best. But visitors had to get to his camp early, because he also shared breakfast with his feathered and four-legged friends. Carter enjoyed telling children about the time a family of desert turtles hatched under his stove. (Courtesy Mandy Tolbert.)

In 1981, Carter began having health issues. To make him comfortable, his sister Alice moved a small travel trailer up to the mountain for his use. She installed a propane tank for fuel and put a water tank in the bed of his Chevy pickup so that he could haul water up from a community well. (Courtesy San Tan Historical Society.)

During his later years, Carter had what he considered more than enough conveniences. He treasured his life, the desert, and the many visitors of all ages. His respect for others' feelings was so great that he would attend to errands after dark, fearing that he might miss a daytime visitor wanting to spend time with him. (Courtesy Rod McGinn.)

One day in 1987, Carter fell and had to be treated at Veteran's Hospital in Phoenix. Soon after that, he was moved into a nursing home. One morning, his sister Alice picked up Maude, Carter's pet quail, and drove the bird to the nursing home. Maude perched on his arm and enjoyed the reunion with her "Man of the Mountain." (Courtesy San Tan Historical Society.)

Mansel Levi Carter is buried on Goldmine Mountain next to his longtime friend and mining partner, Marion Kennedy. His nephew Eugene Bates personally took charge of engraving his headstone. Bates recalls having a terrible time, when all of a sudden, he got this eerie sense that his uncle was there to help guide the chisel. From that point, the engraving went along without a hitch, and he completed the task in no time. Because of this, he knows that Carter is still there on the mountain, watching over his animal friends and the frequent visitors that hike up to revisit an old memory of the Old Man of the Mountain. (Courtesy San Tan Historical Society.)

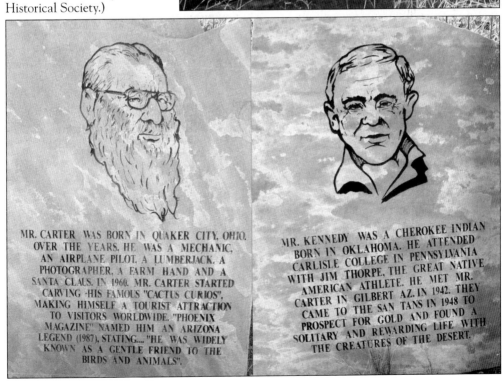

MR. CARTER WAS BORN IN QUAKER CITY, OHIO. OVER THE YEARS, HE WAS A MECHANIC, AN AIRPLANE PILOT, A LUMBERJACK, A PHOTOGRAPHER, A FARM HAND AND A SANTA CLAUS IN 1960. MR. CARTER STARTED CARVING HIS FAMOUS "CACTUS CURIOS", MAKING HIMSELF A TOURIST ATTRACTION TO VISITORS WORLDWIDE. "PHOENIX MAGAZINE" NAMED HIM AN ARIZONA LEGEND (1987), STATING.... "HE WAS WIDELY KNOWN AS A GENTLE FRIEND TO THE BIRDS AND ANIMALS".

MR. KENNEDY WAS A CHEROKEE INDIAN BORN IN OKLAHOMA. HE ATTENDED CARLISLE COLLEGE IN PENNSYLVANIA WITH JIM THORPE, THE GREAT NATIVE AMERICAN ATHLETE. HE MET MR. CARTER IN GILBERT AZ. IN 1942. THEY CAME TO THE SAN TANS IN 1948 TO PROSPECT FOR GOLD AND FOUND A SOLITARY AND REWARDING LIFE WITH THE CREATURES OF THE DESERT.

ACROSS AMERICA, PEOPLE ARE DISCOVERING
SOMETHING WONDERFUL. THEIR HERITAGE.

Arcadia Publishing is the leading local history publisher in the United States. With more than 3,000 titles in print and hundreds of new titles released every year, Arcadia has extensive specialized experience chronicling the history of communities and celebrating America's hidden stories, bringing to life the people, places, and events from the past. To discover the history of other communities across the nation, please visit:

# www.arcadiapublishing.com

Customized search tools allow you to find regional history books about the town where you grew up, the cities where your friends and family live, the town where your parents met, or even that retirement spot you've been dreaming about.